LAUNCHING A
SUCCESSFUL
FASHION
LINE

A Trendsetter's Guide

LAUNCHING A SUCCESSFUL FASHION LINE

RALINDA HARVEY *and* **KATHARINA PRETL**

A & C BLACK • LONDON

First published in Great Britain 2011
A&C Black Publishers
an imprint of Bloomsbury Publishing Plc
50 Bedford Square
London
W1CB 3DP

ISBN: 9781408128824

A CIP catalogue record for this book is available from the British Library

Written by Ralinda Harvey
Illustrations © Katharina Pretl 2011

Publisher: Susan James
Managing editor: Davida Saunders
Copy editor: Julian Beecroft
Page design: Bianca Ng
Cover design: Sutchinda Thompson

This book is produced using paper that is made from wood grown in managed, sustainable forests. It is natural, renewable and recyclable. The logging and manufacturing processes conform to the environmental regulations of the country of origin.

Printed and bound in China

CONTENTS

INTRODUCTION

As a fashion business consultant I've worked with major corporations and individuals, and budgets big and small, to start fashion companies from the ground up – to create something where there was nothing. I must admit I am in a unique field that can make me quite the hit at cocktail parties.

I can't count how many times I've met someone who, once they've found out my profession, has started to tell me about their big idea. A natural denim line made from tree trunks, cashmere socks that come in a zillion colours, tee shirts that say, 'Who's yo mamma?' – I've heard it all. Just before we switch topics, I catch a glimmer in their eye, a flash of hope that if they had the right help then maybe they could really make this dream come true. But after I've given them my card I won't hear from 90 per cent of them ever again.

I have often wondered about that 90%. What if I had been able to quickly lay out the initial steps for them to give them a running start in the fashion business? What if the person could have been the next big name in fashion design, but went back to a miserable pen-pushing job, disappointed? I decided I needed to do something. I couldn't stand by and watch another person's unfulfilled dream die a slow death. So, I paired up with Katharina Pretl, one of the most talented fashion illustrators on the planet, to create what you are holding in your hands right now – an easy-to-read blueprint to help the everyday fashion-lover create their own label.

This book is for all the people who believe they would start a fashion line ... if they could. If that's you, I am here to tell you that you can. Through these pages you can discover if starting a line is what you really want and if so, what it takes to do it. We'll start with the big picture, and then I'll fill you in on some of the more important details you'll need to know as you move forward. So don't let your dream suffer a premature death. Dig it up. Go after it. Give it a chance. Katharina and I will show you how.

RALINDA HARVEY

The secret of getting ahead is getting started.

MARK TWAIN
ON SUCCESS

CHAPTER ONE
STARTING YOUR FASHION EMPIRE

> *So many of our dreams at first seem impossible, then they seem improbable, and then, when we summon the will, they soon become inevitable.*

CHRISTOPHER REEVE

You've been dreaming about starting your own fashion label for as long as you can remember and now you've finally decided to figure out exactly what you need to do to get started. I'm sure you don't want to put off moving forward for one second longer, so let's skip the cocktails, appetizers and small talk and get right to the meat and potatoes.

THE TOP 10 THINGS YOU NEED TO KNOW

to start a successful fashion line

YOU CAN DO IT (THAT'S RIGHT, YOU REALLY CAN)

The fashion industry can be tough, glamorous, ruthless, beautiful and nasty all at the same time. It is not for the faint of heart. That's why, in order to make it in fashion, the most important thing is to believe that you can.

The best way to build your confidence is to zone in on your strengths and focus on what you do well. While you may be a spectacular designer, the thought of selling something might leave you paralysed with fear. That is why it's crucial to do what you do well and be willing to hire and/or partner with people who can do the rest.

People from all walks of life have found success in the fashion industry, and so can you. It's not about having a certain background or an Italian last name. It's simply about being savvy and resourceful enough to make it happen.

A great example is Ralph Lauren, who was born Ralph Lifshitz into an everyday middle-class family. He never went to fashion school and even dropped out of college. His first break in the world of fashion was working in retail, like many who may be reading this book. Yet in 1968 this everyday Joe had the audacity to break out and launch his own company, Polo Fashions, with a US$50,000 loan. Today he's an international icon, with an estimated net worth of almost US$5 billion dollars. While this is a great story, billion dollar companies don't happen by chance. They are a culmination of practical steps that all add up to something big. Therefore,

throughout this book we are going to be very practical about what it takes to start an apparel business. We'll discuss different strategies, techniques and resources you can use to build your enterprise. But before we move on, make a pact with yourself right now to shut the door on those nagging 'what if' questions that love to come around as soon as they smell a big goal. You know those dream-killers that enjoy dressing themselves up like concerned citizens. They say things like 'What if I don't have the right skills? What if my idea isn't good enough? What if I'm just not cut out for this?' The thing about 'what if' questions is that you never get an answer until you try.

So, yes it will take money, yes, it will take time and, more than anything, a truckload of determination. But, if you are willing to put in the work, the best part is, yes, it can happen.

YOU WILL NEED A PLAN

You know as well as i do that things never happen to plan. They just don't. But you still must, I repeat, *must*, have a well-thought-out business plan. I don't mean a cross-your-fingers, best-case scenario. A good business plan should be designed to help you organize your business before you're moving so fast you can't stop – and end up crashing into a brick wall. Wouldn't that be a shame? To avoid this disaster you must force yourself to map out, step by step, the type of business you want to have. The business plan you develop should uncover the different scenarios you may encounter and help you to prepare for them.

Don't fret! Right now, you don't have to write a 30-page business plan. What you need is a business **action** plan.

A business action plan involves simply putting your dream on paper, clarifying your vision and outlining the things you need to do and the resources you need to have to make it happen. Don't get consumed by the details at this point; you

can always fill in the blanks as you go along. (See Appendix I: Business Action Plan Workbook, where you'll find some of the business fundamentals you'll need to understand as you plan, along with some blank spaces where you can start filling in your own ideas.)

A big part of developing your business action plan is talking to a business advisor with some expertise in apparel business strategy, marketing and manufacturing. You'll want this person to help you determine the best options for your circumstances and vision. They should also be able to refer you to key resources such as garment contractors, factories, photographers, designers and sales reps. You'll find that many of the adjunct professors or visiting lecturers at fashion colleges and university programmes also serve as part-time consultants. Another good place to rub shoulders with industry consultants is by attending seminars and other educational events at business associations such as Fashion Group International (fgi.org) in the US, or the British Fashion Council (www.britishfashioncouncil.com) or Centre for Fashion Enterprise (www.fashion-enterprise.com) in the UK.

Your business action plan should be a living, breathing document, which you'll constantly revise at every turn in the development of your business. You're not married to it; it is simply a starting point helping you to to do some research and think through your strategy. Trust me, you'll never regret taking the time to get organized. Your new fashion empire is too important to be left to chance.

GET A JOB

- -

If you're really serious about starting your own fashion business and live within commuting distance of an apparel company headquarters, look into getting a job there. Whether it's as a receptionist, security guard, summer intern or assistant designer, getting in the mix at a thriving fashion business is a wonderful training

ground for learning the ropes of the industry on another company's dime, as well as saving you a lot of time, money and heartache once you start your own.

Working in retail at a store that carries the type of products you'd like to create is also a very smart option since retail jobs are much more flexible and easy to find than jobs at the corporate level.

In a retail store you can get to know the likes and dislikes of potential consumers, understand your future competition, and work to develop a connection with the store buyers who may be your customers when you sell your own line. 'Working [in] retail is important [as] it helps you understand retail and the customer,' says designer Cynthia Vincent who has launched multiple fashion companies, including the celebrity favourite 12th Street Cynthia Vincent and a capsule shoe collection for Target. 'I wish someone would have encouraged me to work in retail. It's [for] a different personality. I'm not that person, but I wish I had that experience,' she admits.

Michael Kors attributes his start in fashion to his stint as a salesperson at Lothar's, a New York boutique, at the age of 19. In addition to sales he was also able to broaden his experience at the store by doing window displays and arranging how the store should look, also known as merchandising. He credits this position with giving him the opportunity to design the store's signature collection, which eventually led him to launch his own collection. A job in fashion retail may not fit the picture of the glamorous fashion job you have in your head, but if you work it right it could be the beginning of something big.

Whatever type of fashion-related job you land, your new job should not be an ordinary job where you just go to work, gossip around the water cooler, and count the minutes till 5 o'clock and the days till your vacation. Your job should be your hands-on classroom, where you'll not only be responsible for doing what's expected of you, but also building the relationships you'll need for your upcoming business. Therefore, along the way on this journey you'll need to make a serious effort to meet and learn from anyone you can.

If you're at a corporate office get to know the production assistant, who is likely to have a database full of pattern-makers and cutters, as well as a long list of factories; or the marketing manager, who is responsible for growing the company, say, to a million fans on Facebook; or the guy who runs the warehouse like a well-oiled machine. If you're working at a retail store get to know your potential target market: what makes them buy, what makes them decide not to buy, what they are

looking for. Pay attention to operational processes such as how often and what types of goods are received in the store, and how they are packaged. If you're working at a smaller boutique, ask the store buyer how they make the decision to purchase a new line.

As you can see, simply being within the walls of the type of fashion organization that fits your future line's customer base can be a huge learning opportunity.

While many designers have been known to work at a particular fashion company for many years, rising through the ranks before they take the leap into entrepreneurship, others do an internship for a short period or work as an apprentice for a few years.

PERFECT EXAMPLE

Gucci Creative Director-turned-entrepreneur Tom Ford started in a low-level PR position at Chloé then, after rising to become Creative Director at Gucci, left to launch his own company with former Gucci CEO Domenico De Sole.

FIND A BETTER HALF

No matter how many great employees you hire, no one is going to invest in the success of a company like another owner. A strong business partner can strengthen your weaknesses and help elevate your company to the next level.

Perhaps they have experience in accounting, management or sales whereas numbers and the thought of even attempting to sell something makes you want to scream. If you eventually decide to go to investors or to a bank for funding, your

skills, accomplishments and work history, as well as those of your management team, could be deal makers or breakers.

Additionally, we simply can't ignore the fact that starting an apparel business can be emotionally taxing. In the company of a partner your wins and your losses can be shared. While it might be nice to feel like you're doing it on your own, even the best of us can benefit from a little help.

To find a partner, if you so choose, use the networks you establish at the job you're going to get or already have or look to old classmates, family or fashion-industry-related groups on social networking sites like Twitter, LinkedIn or Facebook.

Take choosing a business partner very seriously. Even if you already know a potential partner personally, it's imperative to dig deeper before signing your name on the dotted line.

Look at a partnership as a business marriage: although there are some people you might date and have fun with, there are probably not as many you would walk down the aisle with. Once you set up your legal business structure you'll then be legally bound to your partner, and walking away could have a significant impact on your business. After all, like a marriage there's always the chance it could end in divorce.

Whoever you choose, carry out some basic due diligence to ensure you're making the right decision. Consider your potential partner's work history. Are they likely to stick with a job long enough to get some solid experience or will they move on to the next gig as soon as they have a bad week? Do they have good credit? Would you describe them as having an even temperament? How about a general sense of fairness and responsibility? Can they maintain an optimistic attitude even when things get rough? All these considerations will need to come into play as you decide who you're going to spend your business life with.

Follow your instinct, and if someone seems more a convenient pick than a great one, move on to the next candidate. And, of course, although partnerships

can have a lot of advantages, as with getting married, if you can't find the right person you'll probably be a lot happier staying single.

PERFECT EXAMPLE

Designers like Marc Jacobs, Tom Ford and Roberto Cavalli built their global fashion brands with the support of business partners who worked behind the scenes. Take a lesson from some of the most powerful names in fashion and partner up for success.

NEVER BE TOO EASY TO WORK WITH

Do you think of yourself as laid-back, easy-going, cool, calm and collected? Are you the type that's afraid to send back food at a restaurant or confront the co-worker who always takes the last drip of coffee without bothering to refill the pot?

If this describes you then watch out! While an easy-going personality may generally be a good trait to have, it can also make it easy for others more ruthless than you are to run you out of business.

As a business owner, no matter what your authentic personality you must know how to be firm and aggressive when you need to be. As you may suspect, fashion can be very cutthroat. While there are a lot of good people in the industry, it also has its fair share of shady contractors, unscrupulous vendors and people who are only looking out for their own best interest, not yours. So you have to be tough while still being the type of person people like in order to build the strong relationships you'll need for success.

1

This brings me to another topic that often surprises new fashion business owners. Getting good contractors and factories to work with your business can almost feel like a sales job. Many of the good manufacturers make their money from companies producing large quantities which guarantee them a steady stream of business. Small designers, with their small quantities and their high potential to be high-maintenance, are usually shown the door, unless they have one of the following advantages:

A They have already well-established relationships from a company they've worked with in the past.

B They show a strong potential for growth.

C Somebody believes in them enough to help them move from being small fry to playing in the big leagues.

Manufacturers may have been put off by past experiences with start-ups who paid late or not at all, initiated petty disputes or just generally annoyed them because they had no idea what they were doing.

As a new business owner you'll have to combat negative start-up stereotypes from the very first meeting. Show potential contractors you are organized, responsible, reasonable, and that you have both credible financial backing and enough of an understanding of the manufacturing process that you don't expect them to hold your hand every step of the way.

Developing a little chutzpah can only serve you well in all aspects of your life. When you're starting up your business you must be able to stand up and protect it. If you don't do it, who else will?

PERFECT EXAMPLE

One fashion entrepreneur I managed really liked the idea of being liked. She was scared to death of complaining when things weren't made according to her specifications and was seriously conflicted over confronting a factory owner when the high-end dresses they were producing for her looked liked they belonged on a bargain-basement rack. As you can imagine, this type of behaviour may have made her a pleasant person to work with, but drove her business into the ground.

YOU WILL NEED A PLAN

Being a business owner will be different from any job you've ever done before. You won't just get to do your job and go home. And there probably won't be any more work-free weekends just to veg out and watch reality-show marathons.

Working all the time can make for a tough transition from being an employee to running your own company. Designing your products will be just one of your many responsibilities. As the company owner you'll be responsible for creating ideas, building structure, initiating relationships, managing logistics, marketing your business, negotiating costs, handling unscrupulous vendors and making sure at the end of the day that you make a profit. So get ready to step out of your comfort zone to do things that may go against your grain.

If you're unfamiliar with commonly used business software like Microsoft Excel, go on the web and take a tutorial or get someone familiar with the program to show you the basics.

If financial management is not your strong suit, investigate using accounting software like QuickBooks, which is a lot more user-friendly than traditional methods.

The finances behind your business will require your own personal oversight. While you may have professional support in this area, you should never take your eye off the ball. In an issue of *O, The Oprah Magazine*, even Oprah Winfrey cites doing bank transfers as part of her daily routine, and often advises other celebrities on her show that regardless of any business managers, accountants and assistants they may employ, they should always understand the ins and outs of their own bank accounts. If one of the most powerful people in the world has to do this, it's a clue that you should also learn how to be responsible for your own finances. A hands-off financial approach has left far too many people getting screwed over by their partners or accountants. If you don't know what's going on with your books, then you don't know what's going on with your business, and that's never a good thing.

To start building your general business knowledge, read or listen to books or audiobooks about crucial business skills like negotiating, leadership, sales and management. While these topics may sound very big-time corporate, honing these skills can be highly beneficial as you work to make your small business a big one.

To thrive as an entrepreneur you'll have to be better than you've ever been as an employee, so make a commitment to learn the skills that will help you rise to the challenge.

PAINT A PICTURE OF YOUR CUSTOMERS

Without customers you're out of business. It's as simple as that. You need them and they are everything. Basically, do not pass go, do not collect £200 or make any other move until you take the time to understand your customers inside out.

WHO ARE YOUR CUSTOMERS?

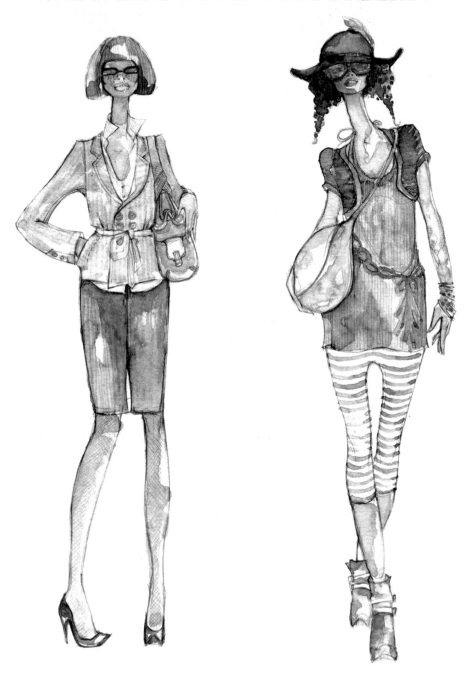

	Jane	**Eve**
PROFILE	Workaholic in a professional dress atmosphere, with minimal free time; loves looking great but not the time-consuming process of shopping or putting outfits together.	Freelance graphic artist with an unstable income but an ability to wear her trendy style everywhere from meetings to a night on the town.
AGE	35–40	25–30
STYLE	Classic with contemporary touches. Label junkie but open to new designers with excellent craftsmanship and timeless style.	Über-trendy, fashionably daring, colourful and eclectic.
INCOME	US$150,000	US$45–55,000
MARITAL STATUS	Single	Single
FAVOURITE STORES	Barneys, Saks Fifth Avenue, company stores of designers such as Louis Vuitton, Marc Jacobs and Dior.	Zara, Topshop, French Connection, and indie boutiques.
HOW SHE BUYS	Almost exclusively online or on her iPad.	Mostly in stores; she loves to touch and feel before purchasing.
WOULDN'T BE CAUGHT DEAD	Looking in the clothing section at Target.	Turning her nose up at a knock-off. In her mind if she likes it and can afford it, she doesn't care whose name is on the tag.
HER FASHION MOTTO	Fashion is an investment.	Clothing is all about creative expression.
HOBBIES	International travel, dining out with friends, visiting art galleries.	Spending the day shopping, clubbing and working out.
WHERE SHE FINDS FASHION INSPIRATION	Style.com, *Vogue*, intercontinental travel.	Celebrity magazines, vintage stores and countless fashion blogs.
STYLE ICON	Gwyneth Paltrow, Jackie Onassis.	Rhianna, Sienna Miller.

Can you understand why a company that markets to an Eve-type customer may be totally different to one that focuses on a Jane-type customer? Each company would be likely to have totally different merchandise selection, sales strategy, price points, marketing and PR plans.

Your customer should guide every decision you make. Start imagining who they are, what their lifestyle is, what their body type is (long and lean or curvy and voluptuous, or both), what type of clothing they want and need, what motivates them to buy, and what makes them walk away.

Never forget, you'd never be able to do it without them. Do whatever you can to understand who they are and what they want.

DON'T EXPECT TO MAKE MONEY RIGHT AWAY

Fashion is much better as a marathon than a sprint. Going too fast can even cause you to implode, essentially wasting everything good you could have created, had you moved at a more practical pace.

It's essential to be very discriminating as you grow your company. You shouldn't sell to every store that may want to buy your products. You'll have to be picky sometimes, even turning down very respectable stores if they don't align with or could damage the perception of your emerging brand.

You'll have to give your potential customers some time to get to know and trust you. You must give the press time to notice you and validate your products with their readers. Overnight success doesn't come often, it can take many years (three or more) to break even with your start-up expenses, let alone make a profit. This is why you need to be financially prepared to start your business and operate it for a while before it can start putting anything back into the pot. To do this you'll need two budgets: a start-up budget to cover getting your business off the ground

1

and an operations budget that contains expenses you'll incur running the business post-start-up. See Appendix II for elements you'll need to include in each budget.

As a ballpark figure be prepared to invest US$50–100,000 to launch your business, depending on the type of products you launch with. For example, starting a T-shirt line is a lot less expensive than starting a line of wool coats since t-shirts cost a lot less to make. We'll talk more about choosing a strategy to fit your budget a little later.

HAVE YOUR OWN VISION

- -

There are so many clothing lines out there. Every celebrity is starting one, every other athlete is starting one, and even big-name designers are knocking themselves off to start lower-priced lines.

But you'll notice, the companies that really stand out and stick around are the ones that have their own vision. You know their line is theirs from a mile away because it has a signature touch that is unlike anything else in the marketplace. Think Missoni with their intricate weaving and colours. Anything that looks remotely like Missoni is automatically reduced to a Missoni knock-off.

While it may be tempting to take major cues from your favourite designers and just incorporate some of your own touches, you should not be simply editing the vision of another collection for your brand. Operating with that mindset, it is too easy to end up looking like a bootleg version of something that already exists, as opposed to a new, exciting company.

As an alternative, start by identifying what it is you love about some of your favourite designers, whether it is clean lines, plush fabrics or vibrant colours. Resist the temptation to focus on just one designer and their overall aesthetic. A better approach is to look to multiple designers and combine elements of each. From

there you can incorporate your own vision, drawing on the inspiration you garner from more abstract things like nature, your favourite city or pieces of art and architecture.

10 FOCUS YOUR ENERGY

There's an old saying that 'everywhere is nowhere'. If you try to do everything in the first year that you've ever wanted to do with your fashion line, the likelihood is that you're probably too unfocused to do anything really well.

Do yourself a favour and focus your collection on ten pieces or less. If you like, you can broaden it with colours and trims so that it appears like a larger range and makes buyers feel they've got enough to choose from. Keep your first few seasons in one category – for example, women's tees – in order to develop some economies of scale around your production and sourcing as well as your sales and marketing efforts.

Establish your reputation with your introductory products before attempting to introduce new ones. Keep in mind that it takes consumers a while to get their heads around what a new company offers. They aren't going to favour your line for everything until you show them that you can do at least one thing exceptionally well. For example, if you make great T-shirts and consumers develop an attachment to your brand, they are more likely to believe in and buy your new hat line, when it appears. At that point, you have proven you can make a good product, as your reputation precedes you. Remember, you plan to be around for a long time. It's good to hold back a little so that you can always give your customers something to look forward to.

TIP: GET IN THE LOOP

I'd be remiss if I didn't advise you to get in the loop, educating yourself in
every way you can in order to stay current on what's happening in the industry.
One thing about starting a new business is that you have to know
what you don't know. As confusing as that proposition may seem, knowledge of
this kind comes with simply talking to people to gain a broader understanding
of the fashion business and putting yourself in the know by reading trade
publications that focus on the fashion industry.

Subscribe to trade magazines like *Drapers* (www.drapersonline.com),
which focuses on UK fashion, *Women's Wear Daily* (www.wwd.com)
and *Sportswear International* (www.sportswearnet.com), or trend forecasting
and analysis services such as World Global Style Network (www.wgsn.com).
You can also be eco-friendly and save yourself a few bucks by
subscribing to the online editions.

THE 12 STEP PROGRAM

to launching a fashion line

1
Set up your business structure

2
Find your team

3
Create your business action plan

4
Develop your brand

5
Design your line

6
Create sales and production samples

7
Find a showroom or sales rep

8
Sell your products

9
Secure your orders

10
Produce mass quantities

11
Deliver to your customers

12
Collect your money

1

DESIGNER
START-UP STORY

Stephanie Lampkin, owner of Odylyne
www.odylyne.com

Stephanie Lampkin launched her bohemian-chic collection Odylyne in 2010 as a side project while she worked full-time at a Los Angeles boutique.

In just one short, whirlwind year she managed to get Odylyne placed in a showroom and sold in over 25 boutiques across the US. She shares with us how she did it and the lessons she's learning along the way.

ON TAKING FIRST STEPS

First I came up with a name, then I started to find people to help me. I found a patternmaker and illustrator who created my first samples by putting ads on Craigslist. When I saw the first piece come to life I really felt like I had something special. It's such a good feeling when you see your ideas on paper and then see your pieces on a hanger.

ON WORKING CONNECTIONS

After getting samples produced I showed them to a friend who also managed one of my favourite boutiques, Madison, which was right next door to the boutique where I was working at the time. She loved the pieces and helped me secure an appointment with Madison's buyer.

ON HER FIRST SALE

Taking the appointment with the Madison buyer was hard and I was probably over-prepared. I had a professional lookbook and even brought a model with me. The buyer was really intense and I couldn't tell if she liked it or not. The last thing she told me was that she'd get back to me, and then a couple of days later I got her purchase order for 300 pieces for all five Madison boutiques!

Stephanie Lampkin

ON LEARNING THE HARD WAY

I found a production company and they told me it would cost US$18,000 to produce the 300 pieces Madison ordered. The guy knew I was new to the industry and tried to scam me. He only fulfilled 75% of the order and was late on delivery. I was able to negotiate him down slightly but I paid for the pieces and chalked it up to experience. I knew I needed to deliver my styles to Madison. I later discovered a fair cost would have been more like $10,000.

ON GETTING A SHOWROOM

After getting into Madison on my own I realized I needed sales help and direction. Since I was already in a great store, finding a showroom was easier than I thought it would be. I walked into one showroom because I thought the line would really fit in there. I just asked if they were looking for new lines and they agreed to look at my stuff. They loved the line and decided to take it right away.

ON MARKETING

I've spent a lot of time doing things to help brand the line, such as shooting a video for our website. Everyone thought I was crazy for shooting a video and it turned out to be a really great marketing tool. I have a blog and update our Facebook all the time. I'll also do giveaways to help promote sales.

1

ON PRODUCTION

Production is so important. You have to ship on time and make sure the fit is perfect and the quality is great. We have one factory that can do jersey and rayon fabrics. This season we have silks, and I'll find someone who's strong in sewing silk. Don't trust one place to do all of your production.

ON BUSINESS PLANNING

Definitely have a business plan. Have your accountant and other business professionals help you organize and plan your business. Know the real costs of your garments and overall how much money you're spending and where it's going.

ON MONEY

You cannot start a clothing line without money. I'd say you need to have at least US$30–40,000 to start up, and that's on the low side. Depending on what you're doing, it can cost $1000 just to develop one sample.

ON THE REALITY OF BEING A FASHION BUSINESS OWNER

At first I had this illusory vision that the fashion industry was so glamorous and all I would do is just sketch and work with pretty fabrics. Outside of sales, I do everything myself from the website to the photo shoot to design and production. I have to make sure my current season's production is running smoothly, while starting to design a new season. It literally is too much for one person.

ADVICE TO NEW FASHION ENTREPRENEURS

I got into Madison in February, then went into a showroom in March. My first delivery was in September of the same year. I would tell new fashion entrepreneurs to take their time, move slowly and figure out what you really want to do.

To be irreplaceable,
one must always be different

COCO CHANEL

CHAPTER TWO
BRANDING

We've all been hypnotized by the power of branding. So what is a brand anyway? How do you come up with a brand name? Or define your unique niche in the marketplace? Let's uncover the mystery behind the branding process and help you discover how to make your to make your brand the next one to watch.

What is the difference between going for a Starbucks and grabbing coffee, receiving a FedEx versus a package in the mail, or carrying a Louis Vuitton as opposed to just a handbag?

A POWERFUL BRAND

The power of a brand transforms something as simple as grabbing a cup of coffee into a cultural experience. The power of a brand makes us rush to open a FedEx box while our regular mail can sit unopened for weeks. The power of a brand is why women walk a little bit prouder when the bag they're carrying is Louis Vuitton. The brand is: the Image, the Promise, the Dream.

FASHION BRANDING 101

If you're in any way a creative type, crafting your brand is going to be one of the most exciting parts of launching your company. Your brand injects your company with personality, emotions and an energy all its own. A brand done right can move consumers to fall in love with you, to trust you like a BFF and place no competitor above you. Sounds good, doesn't it?

Shaping a powerful brand can lead to big dividends if you're able to capture the hearts and minds of your target market. Exactly what type of dividends am I talking about? How about higher profits, new market opportunities and customer loyalty like you wouldn't believe. Trust me, taking the time to create a strong brand will be worth your while. It just takes a lot of thought, a bit of vision and a dash of originality.

So get all your creative juices on deck! In this chapter we'll blend practical theory with some imaginative exercises to help you build the foundation for this fabulous new brand of yours.

WHAT IS A BRAND ANYWAY?

Before we start putting together your blockbuster branding strategy it is important to understand what a brand really is. The concept of branding can be extremely confusing: if you look at 50 different books you'll probably find close to 50 different definitions. Literally. Well, branding isn't rocket science. All the definitions you'll find on the word 'brand' essentially add up to the same thing: brand = expectation (ideas + associations + personality + promise + experience).

Simply put, your brand becomes what your customers think about you.

So when current and potential customers come in contact with your company/ brand what should they think? What should they expect? What should they know for sure? It needs to be something good. If people are going to get excited about your company, let alone open their wallets to buy your stuff, you'll need to give them a good reason.

That reason, whatever it may be, is your **brand promise**. This should be clear, concise, compelling and, most importantly, kept. Through your words and images you must find a way to say: 'This is what I'm offering and this is why it's absolutely amazing.'

BEHIND EVERY BRAND THERE'S A BETTER BRAND PROMISE

2

Let's check out a brand promise in action. When you think of a store like *H&M*, what comes to mind? You may recall seeing *H&M* associated with A-list celebs like Madonna and high-end designers like Stella McCartney and Lanvin. You may picture one of their magazine ads featuring their astonishing low price points. Or you may think of their apple-red logo, an abbreviated version of their full name. What you probably don't think about, are the names behind the initials, Hennes and Mauritz, which sound more reminiscent of a stuffy law firm than a cheap and chic clothing retailer. But we'll talk about naming in a minute. What we need to understand at this point is that 'H&M', written as initials, projects a friendlier, hipper image than 'Hennes and Mauritz' or even 'H and M'. When it comes to branding tiny details can make a huge difference.

So what do the thoughts and images associated with *H&M*'s brand all add up to: *H&M*'s stylish associations + price-driven advertising + handwritten initialled name and logo = a brand promise of cutting-edge fashions at consumer-friendly prices. All of the elements above have been designed to work in perfect harmony to communicate *H&M*'s brand promise.

> *I don't design clothes. I design dreams.*

RALPH LAUREN
ON BRANDING AND DESIGN

BRAND LOVE CONQUERS ALL

- -

New fashion business owners should know right off the top that loyalty is hard to come by. Let's face it, new labels pop up all the time. You're in one day and dreadfully out the next. The industry is just that brutal. In order to grow you need to forge a personal relationship with your customers that goes beyond your best designs. Your brand will help you do just that.

If brands are like people, the brands we love are like our good friends. And just as you choose to closely associate with certain people, consumers also choose to closely associate themselves with certain brands that reflect a lifestyle similar to their own, or at least the lifestyle they aspire to have. Also, in the same way people talk to their friends, brands speak to consumers. They use the same language. They're on the same page. If one friend tells a joke, the other gets it.

Brands are in sync with the customers who love them. Your product is far from the be-all and end-all of a consumer's buying decision. It's only a small part of the equation. Your brand has the power to step in and help buyers understand why you can give them everything they want and more.

BRANDING WITH PERSONALITY

- -

For the stylishly inclined the branding process is a lot easier than it would be for a company without a fashionable leader. Your brand doesn't have to begin with anything heavy like market research or trend analysis. For a lot of successful fashion entrepreneurs, good branding begins within. Some of the biggest brands in fashion are virtually identical to the personalities who created them.

Personality-based brands seem so real and genuine because they are. You may love them or hate them, but the point is they've gotten you to care. As they say,

the opposite of love is not hate, it is indifference. So for better or worse, strong brands grab our attention.

Think about the all-American Tommy Hilfiger, the very pink Betsey Johnson and the urban princess Kimora Lee Simmons, who's the name and face behind Baby Phat. So, yes, it is true that your brand can simply be you.

A FASHION LABEL'S FATAL FLAW – THINKING THE PRODUCT SPEAKS FOR ITSELF

One of the major misconceptions about the fashion industry is that great fashion speaks for itself. It doesn't. Fashion requires the energy of context. Your brand is that context. You don't want consumers and retail buyers to fall in love with one design here or one design there. As with any relationship, sometimes it's better not to have one at all if it's just going to be an emotional rollercoaster. For the sake of longevity your must build a 'serious relationship' not a love-you-today, hate-you-tomorrow type of fling with your customer base.

Ultimately, you want your target market always to love you even if they don't always like you. Some of the world's most famous fashion designers can get their collections bashed by the press but, because of the overall loyalty they've established with their brand, they are invariably given a second chance.

Never forget that brands speak louder than fashion. Make yours one worth listening to.

BRAND EQUITY IN ACTION

Brand equity is the change in behaviour that results from the strength of a brand name. It helps quantify how much of an asset your brand really is. Let's say you're shopping for a dress. You see two print jersey dresses. They're both to die for, have a similar fit and appear to be the same quality. You can't decide, so first you check the price tag. One is US$100 and the other is US$200. When you check the labels you realize one is a designer you've never heard of, while the other is by famed designer Diane von Fürstenberg, whom you absolutely adore. Suddenly the DVF seems a little bit more valuable and a lot more your style. You decide to go with DVF, regardless of the $100 difference, and leave the other dress on the rack. The $100 extra you paid for what was essentially the same product amounts to DVF's brand equity.

Strive to make your brand name such a winner that consumers not only understand the value of your product, but appreciate how much more it's actually worth because it bears your name.

When a company has reached a pinnacle in brand equity, their brand name can turn into a cash cow. A high-value brand can license/lease their name to other companies to create profit from things they don't have the bandwidth to produce themselves. For example, Diane von Fürstenberg has been able to grow into exciting new markets by licensing her name to producers of eyewear, shoes and swimwear.

EMOTIONAL BRANDING — HOOKED ON A FEELING

Fashion is a very emotional business. Unless you're selling tube socks or underwear or targeting a customer base that doesn't have access to a washing machine, people don't literally need your products. So before they buy them they'll need to want them. For that you'll need to tap into your customers' hearts.

Let's take Nike, for example. What are they really selling? When Nike touts the slogan, 'Just Do It!', what they are really selling is a healthy dose of positive motivation. 'Just Do It!' could mean anything. Just Go to the Gym; Just Win the Race; Just Run a Marathon. Nike ads feature visuals of everyone from famous athletes to everyday people 'Just doing it!', whatever 'it' is. The promise is that anybody can 'Just do it!', just as long as they have Nike shoes on their feet.

Without establishing a true emotional connection, your product is just another thing on the shelf. So ask yourself, 'What am I really selling?' Designer jeans or a great butt? An Italian leather handbag or a status symbol? A girdle or a flat stomach?

Understand your customer's emotional sweet spot and target what they want the most.

> *The expression a woman wears on her face is far more important than the clothes she wears on her back*

DALE CARNEGIE
ON EMOTIONAL POWER

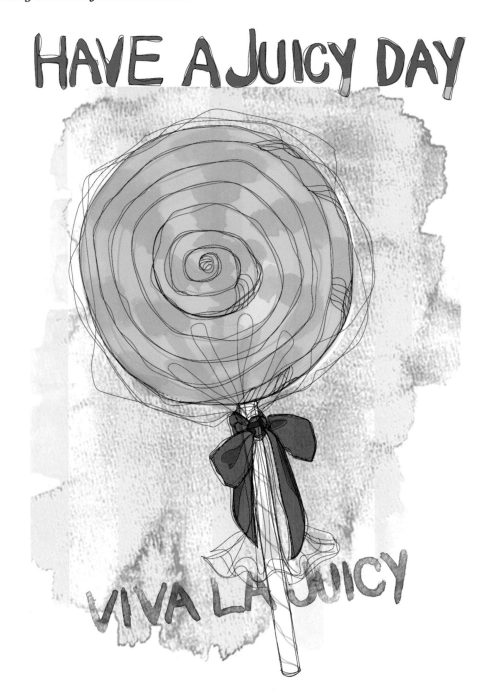

Juicy Couture

A case study in emotional branding

To create a dynamic fashion brand you need to portray a lifestyle people want to be a part of. In 1994 Juicy Couture's founding duo, simply known as Pam and Gela, launched their brand by presenting a whimsical, free-spirited LA valley-girl attitude packaged in a practical, figure-flattering sweat suit.

By sending product samples to trendsetting celebrities (Juicy got its first big PR placement from Madonna), its signature use of crowns, bubble-gum pink colour and marketing messages that urge customers to do everything from 'Eat Candy' to 'Have a Juicy Day', Juicy created a world millions of women wanted to be a part of.

Although Juicy's product was quite ordinary, ranging from T-shirts to terry-cloth sportswear, the brand quickly became larger than life. Women fell in love with being Juicy. They sought the fun, stuff-oriented, high-society lifestyle the brand projected. So they gave the proverbial hand to the mass of knock-offs that sought to benefit from Juicy's formula, in exchange for shiny signature 'J' zipper pulls.

While the free-spirited Juicy ladies would probably never admit to being so contrived as to have a brand strategy, it's obvious how the authenticity behind their brand, rooted in their personalities, has evolved into what has become one of the greatest brand success stories in contemporary fashion. The two owners hit US$47 million in sales before selling Juicy in 2005. The company was purchased by Liz Claiborne for an estimated US$100 million dollars.

WHAT'S YOUR UNIQUE SELLING PROPOSITION

Potential customers need to know why your product is special. They don't have time to figure it out so you need to make it plain. How is your product different from the other products and brands in the marketplace? Why should they choose your products as opposed to something else? The answer to these questions will become part of your Unique Selling Proposition or USP. Your USP will include all the attributes you've given to your product or brand that will allow you to shine in the presence of the competition. These attributes could be things such as a special fabric, unique prints or an interesting design.

IS THERE A USP SHORTAGE?

You may think all the special attributes for your category are taken, especially if you're doing something as common as jeans or T-shirts. If so, take a look at some growing companies that have put their signature spin on some old favourites:

- The designer denim company J Brand differentiates itself in a sea of intricate back-pocket designs by having no back-pocket design at all.
- When baby T-shirts were all the rage the company C&C California stood out by cutting their fabrics on the bias (on a slant instead of straight) to accomplish a signature slenderized T-shirt.
- The jean brand Cheap Monday has been successful using price as their USP. In a world where designer denim is US$200 or more, Cheap Monday has positioned itself as a stylish yet affordable denim brand with an average retail of about US$65.

> *Be yourself;*
> *everyone else is*
> *already taken*

OSCAR WILDE
ON INDIVIDUALITY

POSITIONING: GETTING IN WHERE YOU FIT IN

Brand positioning is how a product appears in relation to other products in the marketplace. It also involves putting your designs in the right setting to maximize your sales and exposure. It can take a little bit of research to discover the best place for your product, but it is more than worth the time and effort.

So how do you get started with positioning your brand? Start by channelling your inner customer. Put yourself in their shoes. Where do they shop? How much are they willing to spend? What brands do they already buy? Think carefully about who they are and what they do.

Once you understand who your customer is, it is time to check out the competition. What brands are likely to be on the same rack, section or floor of a department store as your product? Does your product cost more or less than the competition? What is their unique selling proposition and how is it different from yours?

Finally, think about the best stores for your label. Do you belong in big department stores or small speciality boutiques? How about online stores?

Even your own branded stores? Or all of the above? The more you understand the dynamics of the marketplace you wish to enter, the greater your chances will be of hitting the right spot and hitting it big.

IMAGE IS ALMOST EVERYTHING

You've heard it before: image is everything. It's a snappy slogan but it's not true. Image is a lot, but it is not everything. Strong brands represent strong reputations. People love brands, and for the most part people aren't suckers. Having an excellent product is a key factor.

Remember at the beginning of the chapter we reviewed examples of Starbucks, FedEx and Louis Vuitton. These brands have something worth paying for. They can charge more because they have a certain cachet. But Starbucks isn't constantly serving day-old coffee, FedEx isn't delivering a day late, and Louis Vuitton handbags don't normally fall apart at the seams. They're all excellent products and services. However, their strong brand names give them a leg up over the competition. Good brands make promises and they keep them.

THE NAME GAME

Coming up with a good brand name is a serious business. I mean, who would have thought names like Banana Republic and Abercrombie and Fitch would become some of the most recognized names in apparel? There is no magic formula to coming up with a winning brand name, but a good, old-fashioned brainstorming session is a great way to create a name that is both unique and memorable.

THE BRAND-NAME BRAINSTORMING SESSION

1 Gather a small group of trusted advisers who understand the brand image you wish to project. Make sure you share with them visuals and key words that communicate your brand message.

2 Conduct a no-holds-barred brainstorm. Come up with at least 20 names. No judgments yet – just ideas.

3 Now start narrowing things down to two or three final choices and asking questions. How does it ring? Does it reflect the image you want? Does it sound too much like something else? Is it easy to pronounce? Too ordinary? Too long? Too Short?

When all else fails trust your gut. You'll know the right name for your brand when you hear it.

POPULAR NAMING STYLES

YOUR OWN NAME

Using your own name is an easy default for many designers-turned-business-owners. However, you shouldn't be too quick to use your own name for your company. What if you decide to sell your company or something goes dreadfully wrong and you decide to start over. You've only got one personal name, so use it carefully.

MEANINGFUL NAMES

Many business owners play off meaningful names from people in their lives to create their brand names. For the line William Rast, singer/actor Justin Timberlake

and his business partner decided to combine their grandfather's names. Beyoncé used her maternal grandmother's name as inspiration for her line House of Deréon. Since these names have special significance it helps the brand's owners tell more of a story and has a more authentic feel than something they just made up.

CONSUMER-CENTRIC BRAND NAMES

Names like Urban Outfitters and Forever 21 speak directly to their target customers. Although not overly literal, these word combinations help people realize the essence of the brand. The name and the products associated with the name make immediate sense. The danger in being customer-centric is that you could come across as a little generic, so when using this approach make sure to let your creative juices flow to the max.

TRADEMARK ESSENTIALS

- -

Trademark: a word, phrase, symbol or design, or a combination of these, which identifies a company and its products and services, and distinguishes them from those of other companies.

For a fashion company your trademarks could be anything from the font and colour in which your company name is written to the icon you put on your polo shirt or the signature back pocket of a jean. If you're going to spend the time and money creating something that is supposed to be yours alone, take the time to protect it legally.

The United States Patent and Trademark Office (uspto.gov) has a very helpful website that gives you all the information you need to secure your marks in the US, and even has an online application. If you're wary about interpreting

government application mumbo-jumbo, you can always hire a legal service like LegalZoom.com to help make things easier. In the UK, visit the Intellectual Property Office at www.ipo.gov.uk.

TIP
Trademarks are typically country-specific. For example if you register your business marks in the US, you'll have to follow country-specific procedures to make sure your mark is protected anywhere else you decide to do business.

POWERFUL BRAND ESSENTIALS

Make a point to do more than skim the surface of your branding. People can spot a phoney from a mile away. Here are a few tips to keep in mind to ensure your brand captures the hearts, minds and business of your target customers.

BE AUTHENTIC
A powerful brand communicates its core values and interweaves them throughout the company. Touting your brand as eco-friendly? Everything from having recycled paper hang tags to products made from eco-friendly fabrics helps to demonstrate that your brand is true to its promise.

BE ESPECIALLY SPECIAL
People love things that are especially special. Uniqueness sells. But sometimes designers get caught up in wanting to be better versions of brands that are already on the market. With this thought process you always run the risk of losing what makes you … well, you.

BRANDING

SELL MORE THAN WHAT YOU'RE SELLING

People don't buy just fashion; they buy a feeling. They want to feel better, more confident, more attractive, more professional, more rich, more interesting. You get the picture. Tune in to the emotions of your target customers and create a brand image that gives them more of what they are really looking for.

TELL A GOOD STORY

People love stories. You can tell the story of why you started your line, or give your customers a peek into the inspiration behind the brand. As you establish an attractive brand image your customers will crave to know more. Make sure you have something interesting to tell them.

CONSISTENCY IS KEY

Brands must be consistent and, yes, even predictable at times. Although you may spice things up from time to time to keep your brand fresh, your brand promise, identity and values should remain pretty steady. Consistency builds recognition and, most importantly, trust. Remember, consumers like excitement, not surprises.

MAKING THE BRAND

Many fashion entrepreneurs have an idea of the type of brand they want to create but can't manage to get their desired image across to customers. There is a fine line between sexy and oversexed, clever and cheesy, shabby chic and just plain shabby. A lot of this miscommunication rests in not having a clear vision to begin with. Let's go through a few key steps to help you shape your brand and ensure it comes across exactly as it should.

2

FIND THE WORDS

How would you describe your brand in a couple of words? The descriptive words you choose are the seeds of your brand. Pull out a thesaurus and browse through your favourite fashion magazines for words that communicate your brand's core elements.

CREATE A VISION BOARD

Once you've come up with the right words, it's time visually to bring your words to life with a vision board. The pictures you choose don't have to be for the type of product you're making; they don't even have to be fashion-related at all. They should simply be a reflection of the energy behind the brand you wish to create.

You may want to tear out pages from your favourite fashion magazines or even a lifestyle image from a magazine like *Wallpaper* or *Elle Décor*. Use snapshots you've taken of some beautiful exotic flowers, or a painting you've always loved. Have fun with this exercise. Inspiration has no limits.

CONNECT WITH YOUR CUSTOMER

Now that you're all motivated and inspired, it's time to merge your target market with your brand vision. Define who your customer is and how your brand will fit into their lives. Where do they shop? What do they value? What excites them? Who are their favourite celebrities? What are their favourite magazines? Keeping your customer at the front of your mind will not only give you product and marketing ideas but will help you establish a much-needed emotional connection with your customers.

PULL IT ALL TOGETHER

Finally, it's time to pull everything together. You're clear on your vision. You understand your customer. Now you just have to make sure the marketplace understands exactly who you are.

Since you're a new brand and customers are just getting to know you, the consistency of your message is especially important. Every time your customer comes in contact with your brand, the impression they receive must stem from the same coherent message. Reinforcement helps build reputations, and strong brands have strong reputations.

A good way to manage your reputation is to use certain key words as the ultimate filter for everything that you do. For example, if your key words include soft and feminine, you'll ask yourself, 'Does my latest collection feel soft and feminine in nature? Does my logo read soft and feminine? Is my website soft and feminine?'. If something doesn't fit with your general brand image, take a closer look before putting it in the mix.

ECO LUXE

URBAN HIPSTER

vintage MODERN

SPORTY CHIC

CHAPTER THREE
DESIGN AND PRODUCT DEVELOPMENT

Designer or not, you too can create your own fashion line. In this chapter you'll discover the many creative approaches to design and product development on any budget. Let's take it step by step to turn your concept into something that's actually ready to wear.

THE ART OF DESIGN

Who says you have to know how to draw to be a designer? While it can't hurt, it is not the most important job qualification. What sketching does is give designers an opportunity to communicate their ideas to other people with a stroke of their pen. Fortunately, there are a lot of other and at times better ways to communicate that don't require an artistic hand.

Marianne Gallagher, former Design Director of women's denim for Gap, and the woman responsible for launching Gap women's 1969 premium brand, did not have an innate natural skill at sketching. She graduated from college with a degree in English Lit., and took her first job in the business in the licensing department at Guess Jeans. 'While I was at Guess I took a design class in the continuing education department of a local design college. There is a method to sketching where they could teach anybody how to do it,' Marianne confesses. Ultimately, it was linking up her new-found skill with a naturally stylish imagination that led her to an assistant design job at Guess, a top design post at Gap, and now the launch of her own collection.

So let's take it for granted that you're no Picasso, just someone with a great sense of style who wants to share it with the rest of the world – and make a little money while you're at it.

3

Do you need to go to a design school? The short answer is no, you don't. Design schools typically focus on design and train people to become designers. When you own your own fashion business, design, if you do it at all, will be a fraction of your job.

OK, so you don't know how to sketch, but you still want to design. What should you do? Well you can find a freelance designer or fashion illustrator to help bring your ideas to life. You'll want to find someone who really gets you and where you want to go with your line. In this process you must be an excellent communicator, using physical samples from other designers, images as well as words and other references to get your point across.

In some instances you don't even have to hire a designer to sketch your concepts; you can communicate ideas directly to a patternmaker with a variety of pictures and store-bought samples that exemplify the look you are going after. Many garment contractors prefer to start with a fit sample from another garment to establish the silhouette of a new one.

> *Fashion is architecture: it is a matter of proportions.*

COCO CHANEL
ON THE NATURE OF FASHION

THE PROCESS

When you're starting a fashion line, one of the most fascinating aspects is seeing your ideas manifest into actual garments. So how does this happen? Let's take a look at the product life cycle to see how a spark of inspiration becomes a final product.

THE PRODUCT LIFE CYCLE

THE
★ ★ ★
INSPIRATION

THE INSPIRATION

Form follows thought. Everything has to start with an idea. Keep your eyes open, look around, travel, shop, go to art galleries, watch old movies. Prime your brain for creative ideas.

THE SKETCH OR EXAMPLE

Create a visual representation of your idea. It could be that perfect-fitting blouse you've had in your closet for years: you may decide to replace the collar with one you saw on a blouse in Bloomingdales, change the poplin to silk, and dress it up with a more dramatic version of the longer cuffs that rocked the runway during fall fashion week. *Voilà*! You've just made something simple uniquely your own.

THE
SKETCH

THE
HUNT

THE HUNT

You'll shop to gather everything you need to make your product. Did I say everything? From the fabric down to the buttons and the lining. Buy enough to make a few samples.

3

4 THE PATTERN

You'll gather your sketches, examples, pictures and materials to communicate your vision to your patternmaker. Show them a similar garment whose fit you love; this will give them a good basis for the fit you want to achieve.

5 THE FIRST SAMPLE

After your pattern is complete you'll need a seamstress to sew a sample. This is the magic moment when you see your idea start to take shape.

6 THE FITTING

At the fitting you'll want a real body, known in the industry as a fit model, to serve as the fit standard for your products. You may decide to use yourself or a friend, or else hire a professional fit model.

THE FIRST REVIEW

In the fitting you'll work with your patternmaker and model to work out things that need to be adjusted. Is it too tight in the arms or not hanging the way you'd like? Or is the fabric making whoever is trying it on break out in hives? You and your patternmaker should be taking detailed notes to prepare for the next stage.

THE REVISIONS

Rarely does a sample come out the first time around exactly as you had imagined. Revisions are a normal part of the process. You may go through three or four samples before you strike gold.

THE FINAL SAMPLE

The final sample is the perfect sample, with the fit exactly the way you want it. You'll use this sample as the standard for creating your sizes for mass production.

3

FINDING THE FACTORY

You'll need to find a factory that is capable of producing your goods in large quantities. You may put a couple of different factories to the test. Don't be afraid of asking them to make samples before agreeing to work with them.

10

THE SALE

You'll use your final samples to sell your wares to retailers. You may choose to sell the products yourself or else hire an outside sales rep with good contacts with shops you want to stock your goods.

11

PURCHASING YOUR MATERIALS

Once you have orders for your products, you can place your own orders for mass quantities of the materials you need.

12

GRADING

Your patterns are sized from the final sample to create a full size range. So if the first sample was made in a medium, it would be proportionally graded up to large and down to small.

13

GRADING

MARKING + cutting 14

MARKING AND CUTTING

Before cutting your fabric for production it will need to be marked to make sure the pattern is distributed across the fabric in such a way that you're left with minimal waste.

PRODUCTION

15 **THE BIG PRODUCTION**

Now that all your fabric is cut and you've received bulk quantities of your materials, you're ready to take them to the production line.

 Last check

16 **ONE LAST CHECK**

Arrange to go to the factory on the day your production is supposed to run; take a look at the first piece before they run the full production.

DELIVERY

17 **DELIVERY**

Now that your production is complete, you are ready to inspect your products and start shipping them to stores.

PAYDAY

Ideally, you'd call and get credit-card payment before shipping your order, or else ship the order cash-on-delivery – unless, of course, a vendor has excellent credit and you can afford to wait for payment.

3

FOLLOW-UPS AND REORDERS

Your job doesn't end once the product hits the store shelves. You or your sales rep will follow up and facilitate reorders while you prepare to start the cycle all over again for the next season.

follow-up

GETTING INSPIRED

Sometimes inspiration can seem very black and white – you're either feeling inspired or you're not. When you're competing in the fast-paced world of fashion you don't have the luxury of just waiting for inspiration to knock on your door. It will be your job to go out and find it yourself. When your business revolves around creativity you have to be a little more deliberate and seek out creative triggers to unlock your best ideas.

You can gather inspiration to start your design process from just about anywhere: a celebrity muse, a trip to the museum or images you come across simply surfing the web.

The photo blog *The Sartorialist* is a fun first stop for designers looking for a quick way to experience the best in global style without leaving home. It is produced by fashion sales and marketing executive-turned-globetrotting fashion photographer Scott Schuman, who says he started the blog to 'shoot people on the street the way designers looked at people ... and give design inspiration to lots of people in the process'. The site streetpeeper.com has a similar approach but features head-to-toe style profiles of people everywhere from Amsterdam to Zurich. The best part about these popular blogs is that many images have attracted hundreds of comments, allowing you to see how people all over the world are reacting to certain styles and trends.

For a more business-centred approach to getting inspired, fashion forecasting services offer professional predictions on what's going to be hot for the upcoming season. You may opt for a subscription to services such as Stylesite (www.stylesite. com) or World Global Style Network (www.wgsn.com). These services offer a vast library of imagery featuring the latest runway shows and celebrity fashion, as well as directional colour and silhouette themes you may decide to incorporate into your collection. There are also colour forecasting services like Design Options (www.design-options.com) that forecast the top colour selections long before they've sold out in the stores, and can save you from making the costly mistake of choosing to produce colors that won't sell.

PRODUCTION SHORT CUTS

Companies like American Apparel create blank clothing that can be customized, re-labelled and resold, no strings attached.

Blank clothing producers are able to buy fabrics and trims with huge discounts then manufacture high-quality styles in bulk. So they have advantages in their production process that enable them to make much better products than the average new designer can manage working on their own.

Many contemporary companies were built off the backs of blank clothing producers that freed the owners up from some of the more painful production duties to focus on other crucial parts of the business such as marketing, branding and sales. So don't be ashamed. Check out Alternative Apparel and American Apparel, which are some of the most popular blank companies for casual apparel.

THE BLANK DESIGNER

So how do you express your creativity if you decide to use blanks as your foundation? How about taking blank cotton dresses, professionally softening them, dyeing them in your hand-picked selection of colours and cutting them at a soft angle for added flair? You'd be surprised how different and interesting products can look when you adorn them with your own special touches. By making these products unrecognizable from how they were when you got them, you'll have a line distinctly your own.

WHAT IS MERCHANDISING?

Merchandising is about being the customer filter, taking everything that you've designed and making a decision on what pieces best come together to create a clear vision and of course sell... sell ... sell...

As a fashion designer I was always aware that I was not an artist, because I was creating something that was made to be sold, marketed, used and ultimately discarded.

TOM FORD
THE ART OF COMMERCE

The merchant is the voice of the customer. What would they buy? How much would they pay? What would turn them on? Turn them off? What's going on in their lives? Are they starting to have babies (think: kids' line)? Do they use public transport in a metropolitan city (did someone say cute flats)? Do they own an iPhone (in which case does the purse I designed have a pocket big enough to fit one)? Knowing your customer gives you the best chance to sell to them. As a merchant you understand your customer's lifestyle, preferences, values and finances. You use this information to your business advantage in the form of assortment planning, creating effective sales strategies and marketing.

A strong merchant strikes a balance between the needs and wants of the customer and the needs of the business. They provide just enough choice so that making a decision is a clear-cut, easy and visually enticing process. They make sure none of the pieces in their line are so similar that they give their customers a competing or, even worse, confusing choice (a confused mind tends to say no).

In a new business, as the owner you are likely to be heavily involved in both the design and merchandising processes. That means you'll have to wear two hats, merging the art of the design process with the art of commerce.

A merchant has a lot on their mind, but the main issues will surround the pricing, products, placement, packaging and timing of their collection. Here are a few questions a merchant would tend to think about as they finalize a collection.

What is a merchant?

packaging

product

timing

places

pricing

3

ON PRICING: Are we higher or lower than our competitors?

ON PRODUCT: Should we make this in five different colours or would four be better?

ON PLACE: Should we sell to department stores or online or to boutiques?

ON PACKAGING: Should we sell bikinis as separates or as sets?

ON TIMING: Should we introduce new styles in March or in May?

TELLING STORIES

Telling stories with your collection is a way to create a **seasonal narrative** that **keeps buyers visually and emotionally engaged.** The perfect narrative sparks intrigue and puts your line in context so that people can understand it enough to form an emotional connection.

Retailers also spend a tremendous amount of time creating displays and in-store concepts (also known as visual merchandising) with the purpose of encouraging sales. If you are already presenting a well-merchandised collection, telling a desirable story through style and colour, you've done a lot of their work for them – and guess what: your line has just become easy to buy.

Good stories always have an underlying theme, so your collection should have one too. Make an effort to frame your items in an interesting context that fits with your brand vision.

PERFECT EXAMPLE

A romantic safari theme putting a feminine spin on utilitarian styles and using a colour palette of earthy browns, khaki and green then adding pink as a complementary pop colour that makes the assortment come alive.

This safari story not only makes your collection visually appealing, it also creates an interesting narrative. People love concepts that give regular products context and feeling. When things merge well together, visually showcasing a common theme, it makes the entire collection more attractive, encouraging buyers to buy more and gives them a foundation for marketing your collection.

THE PRICE IS RIGHT

If you price your goods too high your items won't sell, or if you price too low they are perceived as cheap and still won't sell. It can be so confusing. I suggest to my clients that they consider the following three key points before settling on a final price.

1 **HOW MUCH DOES IT LOOK LIKE IT WILL COST?**
 You've studied the competition, you know your customer. Now it's time to make an honest assessment as if you were the customer about to make a buying decision. Ask some objective friends. Considering the brand you've created and the market you're in, what is a fair price?

2 **HOW MUCH DOES IT COST YOU TO PRODUCE IT?**
 How much is it going to cost you to make the item? Many manufacturers use keystone pricing, meaning they mark up items 120–300% depending on how much they think they can get away with.

3 **HOW MUCH DOES IT LOOK LIKE IT COST COMPARED TO THE REST OF YOUR LINE?**
 Be ready to justify your pricing across your entire collection. It has to make sense. Why one thing costs more than another should be pretty understandable.

Once you've gone through this process you'll have settled on a price that fits with your brand and the perception of the garment. However, whether that's enough for you to make a profit may be a different story. If you're unable to mark up at least 120% you're in a danger zone of unprofitability (huge red flag). In that case go back and see where you can cut costs and give yourself some room in your margins. Can you buy different buttons, find a less expensive factory, use a cheaper lining? Aim for low-hanging fruit that can cut your costs without compromising the integrity of your products.

The bottom line with pricing is that your price all has to go back to key point 1, the perceived value. No matter how much you paid to produce something using cashmere lining, Italian leather and master craftsmanship, if it doesn't look like it should cost as much as it does, no matter what marketing you put behind it, it will be a hard sell.

TIP

Early on you'll probably be producing very low quantities, and small quantities translate to higher costs. Don't try passing off this cost on your customer in the form of an outrageous price. You'll just end up not selling at all. As a fashion business owner you're likely to have to deal with a lower margin until you're able to qualify for volume discounts. When calculating cost, use the cost you'll pay once you start buying in volume. Count the costs associated with your first few small production runs as part of your start-up expenses, not the real cost of your product.

> *Luxury goods are the only area where it's possible to make luxury margins.*

BERNARD ARNAULT
ON PRICING

ON THE HUNT: FINDING MATERIALS

One of the easiest ways for new designers to find materials is to visit a lot of suppliers at once by attending a sourcing trade show. A big one is the Magic International Sourcing Show (www.magiconline.com). There are also several put on by the Hong Kong Trade and Development Council (www.hktdc.com) At these shows you'll find apparel manufacturers, fabric and textile mills, print studios and other service suppliers that can help you in your product development.

To get the most out of these shows it is best to walk in having a good idea of what you want. For fabrics find a sample fabric from a garment you have in your possession and look to have it matched.

IMPORTANT QUESTIONS YOU'LL WANT TO ASK POTENTIAL SUPPLIERS

1 ***WHAT ARE YOUR MINIMUMS?***
 Most suppliers have minimums that you must purchase in order to buy from them. Their business model and pricing is based on selling in large quantities. At the same time they know everybody has to start somewhere. They'll often sell you sample quantities at a higher price so you can try the fabric and trims, but after that if you can't meet their minimums you may have to look elsewhere.

2 ***HOW LONG WILL IT TAKE TO RECEIVE YOUR ORDER?***
 Since you don't want to buy your fabric before you have orders, you may have only a small window (two months or so) between the moment when you need your fabric and the deadline for producing and delivering your order to customers. Plan backwards from when you've promised to deliver your products and map out enough time to get your fabric shipped, cut and sewn.

3 ***HOW MUCH WILL IT COST?***
 You'll want to understand everything including the shipping costs, taxes, tariffs, duties and any other fees that may be involved. Even though you fall head-

over-heels in love with a fabric (which is easy to do), if it's out of your range, well, it's out of your range. Remember, you don't only need to buy fabric; you'll also have to have your items cut and sewn and you'll need trims like zippers and buttons and maybe some special finishing or a hang tag. These things add up fast, so make a point of keeping a rolling tab on your total cost for each style so you don't end up being up the creek without a profit.

TIP

Even if you fall desperately in love with the fabric or other materials you find, avoid the temptation to overbuy. You don't want dollars you could be spending on marketing or attending trade shows to be unavailable because they're tied up — even if it is a to-die-for silk chiffon.

TIP

Be careful with jobbers. Jobbers buy excess fabric or remnants from fabric mills and resell them. Since the jobber is not the producer of the fabric they may or may not be able to reorder. Unless you're doing a limited collection you want to make sure you can get more of the fabric you purchase. With jobbers that may not be possible.

SOURCING 2.0

If you aren't up for a trade event, don't worry. You can let your fingers do the walking. Try sites like weconnectfashion.com, ecplaza.net, alibaba.com and www. fashiondex.com to find the supplies and suppliers you're looking for.

DETAILS MAKE A DIFFERENCE

When you're creating product for mass production you'll find the devil really is in the details.

Thelma Siguenza, who's spent over 25 years in garment production and owns of the LA-based pre-production company Garment Solutions, outlines the top three things it takes to produce high quality products that sell.

3

FIT

Without a good fit buyers may buy once, but not a second time. Start the process of producing your garments with a good fit sample. Giving your patternmaker an ideal fit to work from is one of the best ways to communicate what you want.

CONSISTENCY

As you mass-produce you need to have consistency in quality, colours and design. According to Thelma, inconsistency can be the kiss of death for new brands. 'It's like ordering your favourite dish from a restaurant and suddenly they've changed the recipe,' she says.

FABRIC

Fabric is directly related to the fit and comfort of a garment. Make sure the fabric meshes with the silhouette you're creating. Changing the fabric can change everything.

CHAPTER FOUR

FASHION MARKETING AND PROMOTION

Now that you've created your brand, along with prototype samples of your products, you'll need a killer marketing strategy in order to make a name for yourself. From creating marketing materials and getting press coverage to attracting the new media using social networking, let's talk about some key things you need to do to get your brand on your customers' radar.

MARKETING AND BRANDING | THE DYNAMIC DUO

Marketing is how you communicate and generate interest in your brand. In fashion marketing this may include a wide spectrum of activities, from building a website to starting a blog to producing and distributing a lookbook to showcasing your product at a trade event. Each of these tools is designed to spread the word to your target market, persuading them to fall in love with and ultimately buy your collection.

The brand is like the person, their character – what they are all about; while marketing is the mouthpiece – what they say and do. This is why marketing and branding depend so heavily upon each other. If all you have is an interesting brand without good marketing, then your brand will not be exposed to the right people in the right places and will not be selling at its full potential. Branding without effective marketing pretty much defeats the purpose of having a brand in the first place.

The reverse scenario is when you have great marketing and have an opportunity to communicate your message through all the right channels, but

what you're promoting is a lacklustre brand that no one cares about and no one buys. That said, do yourself a favour and invest adequate time in both your marketing and branding efforts so as to bring them together in perfect harmony.

DEVELOPING YOUR MARKETING STRATEGY

4

There are three major things you'll need to consider when planning your marketing strategy.

1

YOUR GOALS

You know you want your brand to be the next big thing, but what does that really mean? Sometimes having lofty and unrealistic goals stops us from achieving any goal at all. Think about your financial resources, talk to sales reps, and find out from other fashion entrepreneurs what they were able to achieve in their first, second and third seasons to use as your benchmark.

Come up with a list of stores with strong brands you'd like to get your line into in your first season. You'll benefit from association with them, and your marketing strategy will evolve from there. Check the online store locators of some of your competitors to start generating this list. Take the next step and get the names and email addresses of the stores' buyers. This can be accomplished in most cases by making a call at the store or reviewing their website. Find out which trade shows and markets these stores' buyers attend, and whether or not they would prefer you to make an in-store/office appointment to see them.

YOUR UNIQUE SELLING PROPOSITION

What do you have over your direct competition? You'd be surprised how designers get frazzled when asked this simple question. What's special about your line should be so clear to you that you could tell someone if they woke you up at 4 o'clock in the morning to ask.

Your marketing vehicles should all have a similar message and theme that continues to bring the point home about why your brand is a must-have for your target consumer. Is one of your key selling points a special fabric, interesting details, exceptional quality? Or maybe just an overall glamorous appeal? Continuously play up your USP in all of your marketing efforts so that it becomes an integral part of your brand identity.

YOUR BUDGET

After you've determined your target market and your unique selling proposition, you'll need to discover the best ways to invest the dollars you have. For example, if your unique selling proposition focuses on special details, you may want to invest more in photography and graphic design so that the value in these details can be communicated visually. When it comes to something like highlighting a USP of exceptional quality, you may want to enlist the services of a professional copywriter for your website, someone who can use their writing skills to drive home just how extraordinary you are.

BUYERS AND CONSUMERS

If you are focused on selling to retail stores, you should concentrate your marketing efforts on retail stores. This means investing in attending trade events, creating a wholesale-oriented website, securing coverage in trade publications prior

to the release of your line, and having all the essential marketing pieces that allow you to present your company as a highly marketable, sellable brand.

The brand association with existing companies that complement your style puts your product into a fuller context. If you are able to sell to some brand-building stores first, the lesser-knowns won't feel like they're taking such a risk.

There are also indirect ways of becoming attractive to retailers. For example if your company builds a grassroots following on your website, it could garner the attention of retailers wanting to capitalize on the buzz you've created. Therefore you should always work to stir up your own buzz. Fortunately, this can be done without too much expense using social media channels and the web. Social media expert Macala Wright talks about exactly how to do this later on in the chapter.

YOU NEVER GET A SECOND CHANCE TO MAKE A FIRST IMPRESSION

Retailers are looking at your marketing materials not only to get more information about what you have to offer but also as a barometer for how together your new company actually is. Amateur, incomplete or sloppy marketing materials can be major indicators as to whether a company will deliver on time, have products that fall apart or project the type of image the boutique wants to associate with.

THE MARKETING MIX: THE WHOLE IS GREATER THAN THE SUM OF ITS PARTS

Put a variety of marketing vehicles together to give your brand the exposure it needs to grow.

Your marketing mix may include producing and mailing a colour catalogue to your top 100 prospects, exhibiting at a trade event, launching an interactive website or building a following for your brand on Twitter. These events happening together in the right order can be much greater than the sum of their parts. Therefore you should plan them out strategically.

In practice you should be able to use your colour catalogue as a mailing to persuade your top 100 prospects to visit you at a trade event. Assuming they come to the show and you manage to acquire their email address, you can then reach out to them, directing them to your website, where they can chat with you or comment on your product, and where they'll also find links and reasons such as special promotions or engaging content to join your Twitter feed or Facebook group.

Make a point to consider all your prospective marketing events as a whole or you're bound to get distracted by lots of little things that don't add up to much. One of the worst mistakes designers make is taking too many bets on fun things to do that have little to no sales potential. Fashion shows are the biggest culprit, being primarily brand-building activities that are tremendously expensive and still need to be followed up with sales efforts.

Another big offence is blindly sending samples to celebrities and the press. Your samples are expensive; you can't just send them out on a wing and a prayer. Your initial approach to the press should involve mailing or emailing a link to your lookbook, followed up by a phone call or email to see if they'd like to request samples.

Celebrity placement often begins with the help of a well-connected PR person. Retaining a PR company could be your best route to participating in things such as Oscar or MTV awards gift bags as well as gifting suites at venues such as the Sundance or Cannes Film Festivals. If there is another designer in your category that seems to do great PR, check their website – often press contacts are listed that you can approach about representing your brand.

MARKETING MUST-HAVES

Your marketing materials are the first representation of your brand most
potential buyers will see, and with all the lines out there clamouring for attention,
you'll be lucky to have one chance to make a first impression. There are so many
ways to market yourself and your brand. Here are some essentials you'll need to
get started.

BUSINESS CARDS

Who said business cards were so 1989? Well, think again. Even in the age of
scanning barcodes into your BlackBerry or bumping iPhones to share contact
information, the business card is still a top networking and marketing tool. It's the
first thing you hand out after introducing yourself and explaining what you do.
It comes at the end of a conversation with a new contact. 'Give me a call. Here's
my card.' You know the game, and you have to have cards to play. So make them
good ones. If you're an avid social networker, an interesting, fashionable, frequently

updated Facebook or Twitter account could also function as a virtual business card. But when you meet someone in person you'll still need the printed card to direct them to your social pages.

People in the fashion industry are attracted to things that are beautiful. They have no problem judging books by their covers. Make your cards fashionable and open the door to them being attracted to you.

FIVE TIPS FOR CREATING FABULOUS BUSINESS CARDS

DON'T BE CHEAP

Yes, I know you're a start-up and money isn't growing on trees, but invest in some heavy cardstock, professional design and quality printing. Having a cheap-looking business card is like wearing a cheap suit. It says a whole lot without saying a word. Fortunately, there are many online sites, such as vistaprint.com, where professional printing doesn't cost an arm and a leg. You can also enquire with your local printer about professional laser-printing options, as these are a lot cheaper than traditional printing.

AVOID AMATEUR TITLES

Although it may be tempting to immediately award yourself the title of CEO or president, that just screams start-up. Always aim to project the image of a company that's much bigger than just you. Use your title to make yourself appear part of a bigger picture. Try on a mid-level leadership title for size, such as Director of Sales, Business Development, Merchandising or Design. Not only does a mid-level title allude to a stable, more established organization with various layers, it

also allows you to show a little humility as well. If the opportunity arises where it's more advantageous to let people know you are the company's owner, it's always there for you to pull out of your back pocket.

3 GET A BUSINESS ADDRESS

Maybe you don't have a luxury office suite, but that doesn't mean you can't still have a luxury business address. Mailbox stores or PO boxes make it economically feasible for you to fake a more cosmopolitan business address than your home on Maple Drive. It's also a lot more secure than handing out cards that include your home address.

4 ADD SOCIAL MEDIA CONTACTS

If your business maintains a Facebook fan page, Twitter account or other social-networking connection (which it should!), put that information on your card.

5 BRAND YOUR EMAIL

Many people also still insist on using their own domain with something like mybusiness@gmail.com. This is tacky. You're a business owner now, and every little detail about you (including your email extension) needs to further brand your company and communicate that you are running a serious business. So buy your domain name, and create and use an email address that correlates with your web address.

OTHER MARKETING ESSENTIALS

LINE SHEET

A line sheet is a fashion-industry term for a buyer's sales catalogue, making it one of your most crucial sales and marketing pieces. It's nothing extremely fancy, nor do buyers expect it to be. What it should include is all the information needed for a buyer to actually buy, including a sketch or photograph that outlines all the detail of a style: the style name, delivery dates, 'order by' dates, the style number, prices (wholesale and suggested retail), and the available sizes and colours. As a header and footer on your line sheet or sheets, include the full contact information of whoever is selling the product, whether it's you or your sales rep.

A NOTE ON STYLE NUMBERS

Create a prefix system for assigning style numbers to each of your styles. Of course, you can give your styles names as well (for the sake of branding), but style numbers can make it easier for you to reference and organize styles even years down the line. For example, if you have a swimwear line you may start all one-piece styles with a 01, bikini tops with a 02 and bikini bottoms with a 03, and then add two or three extra numbers to make a unique code. This way you only need to remember your prefix and two or three numbers to reference a style. This is much easier than having to recall whether 'Bianca' is a top or a bottom. You can also start your numbers with a season code such as SPR or FAL to add further context.

line sheet

AUTUMN DELIVERY
DELIVERY DATE: JULY 15TH
ORDER BY: JUNE 1ST

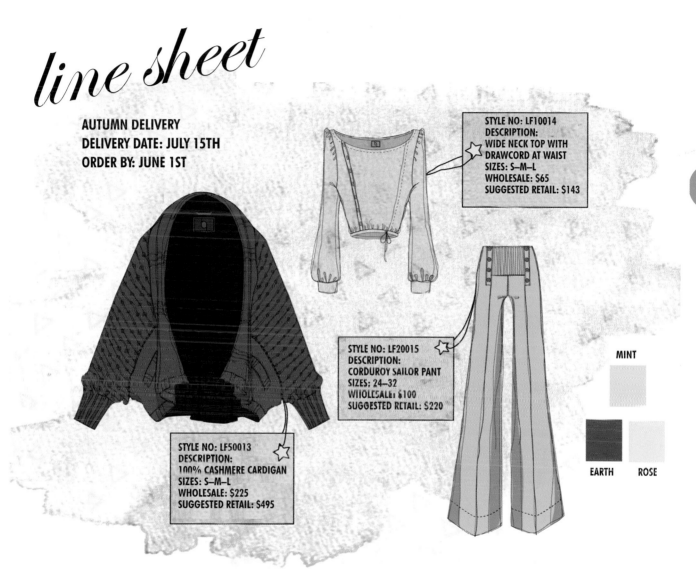

STYLE NO: LF10014
DESCRIPTION:
WIDE NECK TOP WITH
DRAWCORD AT WAIST
SIZES: S—M—L
WHOLESALE: $65
SUGGESTED RETAIL: $143

STYLE NO: LF20015
DESCRIPTION:
CORDUROY SAILOR PANT
SIZES: 24—32
WHOLESALE: $100
SUGGESTED RETAIL: $220

STYLE NO: LF50013
DESCRIPTION:
100% CASHMERE CARDIGAN
SIZES: S—M—L
WHOLESALE: $225
SUGGESTED RETAIL: $495

MINT

EARTH ROSE

YOUR SHOWROOM CONTACT INFORMATION GOES HERE

4

LOOKBOOK

While a line sheet should be clear and straightforward, expressing every little detail about your products, a lookbook is your chance to really express your brand with artistic shots, styling and other branded elements like backgrounds and props that tell the story of your brand. But if backgrounds and the like are simply not your brand's style, don't worry: simple shots on clean backgrounds can work equally as well.

Producing your lookbook in an electronic format only is both ecologically and economically friendly, but there is no real substitute for handing out something tangible, such as a printed lookbook, during tradeshows and other sales interactions. People like having something they can feel.

The problem with lookbooks is that they can be terribly costly, especially if you're producing one for every season. Between paying for a photo shoot, hiring models, retouching images and for layout and graphic design, developing a lookbook can add up to big bucks, meaning several thousands of dollars even on the low end. Look for ways to lower your costs by negotiating bargain-basement rates for photography, models, hair and makeup by offering in exchange copies of the final photographs or products from your collection. Also, speak with your printer about options that will reduce costs, including bulk discounts and finishing options such as having pages stapled in the centre – this is much cheaper and still looks good – as opposed to having them bonded with glue.

TIP

Although traditionally line sheets are pretty straightforward, some innovative designers have combined the function of a line sheet with the style of a lookbook. Don't be afraid to combine these two: as long as you include all the information a buyer needs to buy and you don't plan on making too many changes. After all, it is possible to have both fashion and function.

WEBSITE

It should come at no surprise that these days a website is a serious must-have. This essential marketing tool can be set up to work harder for you than any other five marketing tools combined. Start by researching websites of fashion brands you love for ideas on layout and functionality. Based on your research, sketch out the flow and pages for your own site to communicate to a web designer how you'd like your site to be. If you've worked to create your logo with a graphic designer who doesn't normally create websites, you may also decide to hire them to collaborate with your web designer/programmer to produce your site. The graphic designer could provide a style guide (meaning a colour scheme, photographs, fonts and other imagery) that a web designer/programmer can carry through to other pages on the site. A graphic designer can also design all the pages, leaving a web designer simply to program them in Flash or HTML.

4

TIP

Make sure your website has a store locator that you update frequently. Buyers will want to know that your site is there to help to promote them too.

BIOGRAPHY

Create company stationery with your logo to print out a bio about yourself and/or your brand. Repurpose the material you used for the 'About Us' page on your website.

FABRIC CARDS

If the fabrics or colours you use are a strong selling point, you should (at least for the most important stores) cut out actual fabric swatches to give buyers an opportunity to see the vibrancy of your colours or prints as well as experience your luxurious fabric. If you can't cut out actual fabrics, good colour copies will do the trick.

POSTCARDS

Postcards are an inexpensive and easy way to promote your brand from one season to the next. Showcase a key item or even a few of your most exciting styles. Always make sure to have a call to action such as 'Visit our tradeshow booth during the designers' and agents trade event', or 'Last call for orders for a particular delivery', or even 'Promoting a first-delivery deadline', or 'In-stock styles that can be delivered immediately'.

TIP

Print out a batch of postcards without specific information and use stickers for specific details that could change, such as delivery dates or trade show booth numbers.

ORDER FORMS

You can create your own order forms, to be used when buyers place an order with you, or if you're working with a showroom they may have their own standard order forms that they use for all their clients. Buyers may also submit orders using their own purchase orders. Either way, the form from which an order is submitted should contain:

Delivery dates: This is the date when the product will be shipped from the designer.

'Cancel by' date: This is the date by which time, if the order has not been shipped, it will be considered cancelled.

Terms and conditions: You should attach terms and conditions for the sale dictating cancellation policies and payment terms.

PACKAGE IT UP: YOUR MARKETING KIT

Package your printed marketing essentials in a branded folder that can be used as a complete kit to hand out to buyers and the press at tradeshows and other industry events. Include your lookbook, line sheets, biography, order forms, fabric cards, postcards, printouts of press coverage and any other marketing pieces which may help you sell and brand your company.

BONUS MARKETING MATERIALS

There are plenty of other tools you may want to add to your marketing mix to increase your impact on your target audience. Here are a few to consider:

1 **SOCIAL MEDIA PAGES**

 Maintaining Facebook, Twitter and other social media pages can be a great way to continuously connect with your buyers and consumers without pursuing them incessantly with emails. Many designers give fans insight into their design process, their inspiration and their everyday lives to try and form an emotional connection. Check out Twitter queens Rachel Roy and Tory Burch for ideas.

2 **BRANDED PACKAGING**

 Have you ever purchased something just because the packaging was super cute? I know I have. Packaging can give your products a higher perceived value, leading you to increased profits and brand exposure. The Australian company Macher.com is famous for creating stylish packaging solutions for the fashion and beauty industry.

3 **HANG TAG**

 If you're producing a premium product, a hang tag is fundamental. It can be as simple as having your logo printed on heavy cardstock or it may include some copy about why your products are so awesome.

YOUR FIRST PHOTO SHOOT

Doing a photo shoot for your marketing materials requires a little bit of research and a lot of coordination and negotiation. One of the biggest challenges in producing a great shoot is finding the right team to give you the end product you're looking for. Since you're a start-up you'll need to watch your cash and be extremely careful not to overspend. I've listed a few techniques to help you get the best for your money.

1 HOOK PEOPLE UP

The creative industry thrives off collaboration and portfolio building. When searching for a creative team to produce your photo shoot, use strategic collaboration to your advantage. Many creative professionals will take unpaid jobs with the sole interest of building their portfolio. For example, a professional studio photographer may want to add some location shoots to their portfolio, or a beauty photographer may want to take on a fashion gig to broaden their range.

Also, don't hesitate to use the portfolios of confirmed collaborators as financial leverage to build your team. You may be able to get some people on board just by giving them the opportunity to produce a final product with someone whose work they admire.

2 USE AN AGENCY

If you live in a big city like New York, Paris or London, consider calling on top modelling agencies such as Ford, Elite or Wilhelmina to find a model. Of course, they may represent Gisele, Naomi and the entire squad of Victoria's Secret Angels, but they also rep up-and-comers who are gorgeous but struggling

to pay the rent. Reach out to the agency and explain your project and what you're looking for in a model.

You can be sure that within the first minute of conversation the agency will ask how much you have in your budget. Push back by requesting a range of fees for some of their new or less experienced talent.

If what they quote still falls outside what you can afford, don't be afraid of making more attempts to negotiate based on the reputation of other collaborators involved, the type of product or the scheduling.

An entry-level price for a good professional model is about US$1,000 a day, although under the right circumstances an agent may be able to get a model to work for a bit less. I once got an agent to agree to 50% off a model's going rate. He told me she wasn't working that day and she might as well get up and make money instead of sitting at home.

SOCIAL NETWORKING

Many undiscovered models have their own Facebook pages or pages on sites like modelmayhem.com. If they are not repped by an agent you're likely to get a much better rate, as agents typically take about 20% off the top.

TIP

An agency will quote you a price for a model either with or without an agency fee. Make sure you are working with the total rate, including the agency fee, since that is what you will ultimately have to pay.

PLANNING TO SHOOT

You have your model, location, photographer, hair and makeup, and maybe even a stylist lined up for the big day. Don't make the mistake of having everyone just show up on shoot day to figure out what to do. I've never been to a photo shoot that didn't fly by, and the day of the shoot is no time for last-minute planning: it should be all about shooting. Connect the dots before the big day so you and your team can hit the ground running.

THE PHOTOGRAPHER

Collect tear sheets from magazines or websites that depict the look and feel of the photography you're looking for. Review your concepts with your photographer well in advance of the shoot, as they may require using a special camera or lighting to accomplish the desired result.

THE MAKEUP AND HAIR STYLIST

Share raw, un-retouched pictures of the models you're using so your hair and makeup people can see what they'll have to work with on the day of the shoot. Also provide them with photos of the type of makeup you're looking for (which you can gather from magazines, websites or even the artist's own portfolio). Have an idea of the type of look you want to achieve for each shot and your hair and makeup artists can build out the details. Are you looking for old Hollywood glamour with cherry-red lips and big bouncy curls, or a fresh and dewy natural look where hair is pulled into a low chignon? Enquire about any compromises you may need to make with your hair and makeup team, such as minimizing changes or complicated looks in the interests of staying on schedule.

THE STYLIST

A stylist's job consists of deciding the mood of the look and pulling all the elements together for the perfect shot. But, don't stress out about outfitting a model from head to toe. It's normally best to concentrate on keeping the main focus on what you're actually selling. When it comes to accessories go for subtle details like delicate bracelets, necklaces or other articles of clothing that put your wares in context without overwhelming them. For example, a great-fitting plain tee and sexy stilettos may be great for a jeans line, but a trendy belt might be so interesting that it steals the show. Details like bold glossy lips or red nail polish also double as accessories as they can add a splash of colour or detail to the picture. Also, it's customary to ask models to bring some of their personal items such as jeans or jewellery.

THE LOCATION

Deciding where to shoot could be as simple as using your photographer's studio or finding an alternative location, commonly referred to as shooting 'on location'. New designers often keep it clean, using a photographer's studio, while others opt for low cost options like a local beach or park, their own homes or those of friends and family. If you're shooting on location, check with local government agencies to see if any permits are required. You certainly don't want to set up and secure talent only to get ticketed and asked to leave.

Before the day of the shoot send out a call sheet to make sure you have signed deal memos or contracts for all the players. Deal memos confirm the rate for your talent, and function as a signed agreement that the person is actually going to show up on the date of the shoot. You could also produce a call sheet, essentially a document that fully prepares your team for shoot day, including the time they should arrive, directions, parking instructions, phone numbers (yours and those of anyone else coordinating the shoot), and instructions to models on what they should bring, including things like a push-up bra, hair extensions, jeans or heels.

ROCK THE RUNWAY ... OR NOT?

I know every designer dreams of their first runway show, but a big fashion show like Fashion Week in Milan, London or New York, or a fashion show in general, is not anything you should be concerned about when you launch. You may decide to put a fashion show in your marketing plan and budget for year three or four, but definitely not year one.

Why not? Fashion shows can present the expense of hiring multiple models, hair and makeup people, production assistants, and everything else needed to put on a successful live event. Even if you are lucky enough to secure sponsorship, actively producing a fashion show that you love enough to stamp your brand name on takes up a lot of time – that might be better invested in other things. For instance, mapping out your infrastructure and working out the inevitable kinks faced by every new business, such as product quality control, building new business relationships and process development, are bound to be more important issues.

GETTING PRESS COVERAGE

Tasha Nita Adams, founder of the lifestyle blog mondette.com, has also been a fashion writer for *Variety's* 'The Stylephile' and covered tradeshows and fashion weeks for World Global Style Network. 'It's an exciting time,' Adams says, referring to the growing star power of the blogosphere. Here we get her take on how new designers can get a little love from blogs as well as print publications.

DOES REPRESENTATION MATTER?

Acquiring a showroom or a PR rep really helps. In the magazine world you get so much pitched to you and a lot of it is crap. So the industry becomes a lot about relationships. If someone from a showroom or a PR person that I trust calls me, I'm much more likely to take a look. If I get something from someone I trust, I know it's likely to be something I would be interested in covering.

IS OLD OR NEW MEDIA MORE IMPORTANT?

Fashion bloggers have more reach than ever. Even magazine editors are inspired by blogs. Everything works together.

WHAT'S THE PROTOCOL FOR REACHING OUT TO BLOGGERS?

Send a personalized email to the blogger. You can include a press release, but overall keep the communication short, friendly and professional. Let them know you're a fan of their blog and you'd like them to take a look at your line. Also, send them a lookbook, images and a link to your site. Attachments are OK, but test your email before you send it out and make sure you're not sending images that are either too big or too small.

HOW CAN YOU TELL WHICH BLOGS WILL GIVE YOU THE BEST EXPOSURE?

Look at what the blogger is paying attention to. You can check who their followers are, which can tell you a lot about who they are. Bloggers have to disclose if something they're covering was given to them, so it becomes this whole status thing. If they blog something like 'Juicy Couture sent me this', it says something about the reach of the blogger.

WHAT MAKES A BRAND ATTRACTIVE TO THE PRESS?

Authentic brands with quality products, an interesting story and a strong point of view. It's also a big plus if the people behind it are friendly and helpful, making

Tasha Nita Adams

4

Tasha Nita Adams

the information-gathering process easy. Have documents with proper information such as wholesale and retail prices, in-store dates and a list of stores in which your products are stocked, now and into the future. Finally, be nice. Fashion can be a pretentious industry, so people who are nice stand out.

WHAT ANNOYS THE PRESS THE MOST?

Although you want to show that you are familiar with a publication, don't ask for a specific type of coverage. It's a big turn-off if someone starts off by asking for the cover. Also, always err on the side of professionalism in your communication watch your grammar and don't forget to spell-check. It matters.

IS IT OK TO FOLLOW UP?

Follow up in about a week. They're a lot of times people contact me and I don't get to it till the second contact.

PRINT MAGAZINES

- -

Let's take for granted that you don't have the inside track at your favourite magazines and that you're not yet in a position to hire a PR agency. So what's a new brand to do to get a little attention? Follow the steps below to give the press your best shot.

1 **CHECK OUT THE PUBLICATION'S EDITORIAL CALENDAR**
 Go to the magazine's website and look for a media kit or editorial calendar to see what themes they are planning on working on for the year ahead, and

where your line may fit in. For example, if you're a women's denim company you may notice that in *Marie Claire*'s editorial calendar they have a denim guide coming in their May issue, for example, or that *Glamour* has a romance feature in February that would be perfect for the Victorian ruffle blouse in your collection.

2 ***FIND THE RIGHT CONTACT***

Find the market or fashion editor's name in the masthead (the directory of names and titles featured on the first few pages of a publication). Mail or email that editor a press kit including a cover letter or press release, your lookbook and line sheets. Never send unsolicited samples, as you're unlikely to get them returned and they may never be photographed.

3 ***SEND YOUR SAMPLES PROPERLY***

If the editor reaches out to you, send them the samples they've requested along with a packing slip or invoice that includes all the styles you're sending and their wholesale prices. Make sure each piece is tagged with the style name, style number, and the retail price for a consumer publication like *Elle* or *Glamour*, or a wholesale price if you're mailing to a trade publication such as *Women's Wear Daily* or *Fashionmag.com*.

THE ART OF THE EMAIL

Email marketing can be extremely effective and much cheaper than reaching out to buyers via snail mail. However, email marketing is slightly more complicated than sending an email out to personal friends. In email marketing if you don't email responsibly you can get banned from sending mass email to certain email domains, and you can even run into legal trouble.

Here are a few things you should know if you want to carry out email marketing in a responsible manner.

GET PERMISSION

In order to email marketing messages without them being considered spam you must acquire permission from the recipient. This means you either have to meet them personally or they have to opt in to your website. To help build your database make sure you have an 'opt in' section on your website where visitors can add their emails. Also, collect emails of prospective buyers whenever you get the chance. At the same time, just because someone exchanges cards with you, it doesn't mean you're free just to add them to all your mailings. People get easily turned off if they haven't specifically acknowledged they want to receive your marketing.

USE AN EMAIL SERVICE PROVIDER

Email service providers, also known as ESPs, such as constantcontact.com and campaigner.com help you organize your email communications, ensuring your emails are delivered. By using an ESP you can see who opened your messages, clicked through and even forwarded them on. Whatever you do, don't send a long email with a hundred 'cc's. It's not professional and is likely to go in a spam filter.

STAY RELEVANT

Limit your email communications to when you have relevant, timely things to offer. Introducing a new season and an upcoming trade show, or sending out a last call for fall deliveries may be newsworthy. However, random messages every week about new styles or press coverage, or even a Happy New Year message, may just be irritating and get lost in the clutter. These types of announcements are best communicated through social media sites. To be a good email marketer, figure out

what is relevant to your customers and only reach out to them with marketing you think they would appreciate or might act upon.

TRUNK SHOWS AND VIEWINGS

Trunk shows or private viewings are publicity and pre-sale events that can give an invite-only crowd the opportunity to view, buy or order products before the collection is made available to the general public. You may decide to do something shortly before your orders close for a particular season, so that you can tack any orders from the show onto your final production run.

These exclusive fashion events can take place just about anywhere, but boutiques or department stores are the most obvious settings, with built-in audiences they can invite. Dress up your event with refreshments and/or provide styling services to showcase how your brand can be worn with other products in the store. When you team up with a retailer for a trunk show or viewing, they can assist you with the marketing and provide you with the space in exchange for a percentage of the sales proceeds.

The boutique you work with is operating at a low risk when they host your trunk show, since they can sell products without having to buy them upfront. A trunk show also serves as co-marketing opportunity. While the boutique may extend an invite to their best customers as thanks for their loyalty, you can do some outreach to bloggers and the press to draw attention to both their store and your brand.

You could decide to do a trunk show in your first season, if you're able to find a willing retail partner, or you may have to wait a few seasons until you make a bit of a name for yourself to attract enough of a crowd to make the event worth the time.

WORKING THE SOCIAL SCENE

successfully marketing your brand with social media

Macala Wright Lee

FOUNDER, FASHIONABLY DIGITAL

Social media is a crucial element in a fashion designer or brand's success. It allows a brand to build brand awareness, reach new customers, maintain relationships with current customers and generate online sales through word-of-mouth activities.

Here are five strategies you can follow through social media to help successfully market your fashion line online.

1 HAVE ACTIVE PRESENCES IN SOCIAL COMMUNITIES AND CURATE THEM WITH YOUR OWN CONTENT

Every brand should have a presence on Facebook and Twitter as well as their own blog.

Twitter is the easiest way to connect with people online. Twitter allows users to find and follow people who interest them. You can use Twitter to build a customer as well as retail-business base. When you tweet, write about what you are currently involved in, reading or find engaging; people like humanity and personality.

Every brand should have a Facebook page (not a Facebook group) that enables people to 'like' the brand. When someone 'likes' your brand, it connects him or her to your brand's page on Facebook. Most brands use their Facebook page as a marketing tool by providing educational, informational or engaging content aimed at getting a response from the brand's fans. Three brands doing this very well are LuLuLemon, Athletica, and Hayden-Harnett.

Creating your own content. Every designer and brand should have their own blog, and that blog should feature content related to the brand, its products, its customers and the designers who founded the fashion brand.

2 PARTICIPATE IN AND BUILD RELATIONSHIPS IN NICHE FASHION COMMUNITIES

Sites like Senseofashion.com, Polyvore.com, LOOKBOOK.nu and Kaboodle.com, allow you to create free accounts as a brand or individual designer. Social fashion communities' designers do a variety of things, including:

Obtain feedback on apparel and accessories in product lines. By adding photos to MyItThings.com or Senseofashion.com, designers can upload photos of their collections so that community members can leave comments about them or vote on things like their favourite colours or styles. Letting others provide feedback on your designs is called 'crowdsourcing'. Crowdsourcing customer opinions is how online retailer ModCloth.com built a multimillion dollar company. Senseofashion.com is also an international marketplace, as the site allows you sell your collections directly to customers; it's a feature worth using if you want to make money directly from online shoppers.

Polyvore.com and Kaboodle.com allow brands to add photos of the pieces in their collections (apparel, accessories or footwear). Both sites have 1.1 to 2.2 million registered members. These members can use the photos to create their own photo sets and embed them in their own blogs, Facebook pages and Twitter accounts. Can you imagine the possible exposure and sales that could come from people using photos of your product line in their social activity? There is a lot of potential. Both Polyvore and Kaboodle allow e-commerce links so that community members can buy your product online.

As a designer, we know you have style, so don't tell people – show them! Fashion sites like Chictopia, Modepass and Fashism, allow members to upload photos of what they're wearing. Site members then vote on the looks they like most, earning points or other recognition rewards. When members create sets, the person who created the set lists what they're wearing and where they got it. Having your product featured in social fashion communities builds brand awareness and gradual, organic sales of your product. In order to be featured, you can provide your product to style bloggers who are members of their communities, or if you're a small brand, you can take photos of yourself and submit them. After all, no one represents your product better than you!

USE DIGITAL EXTENSIONS OF TRADITIONAL MARKETING MEDIUMS

As a designer, a lot of people tell you that in order to launch a successful fashion line, you will have to spend a lot of money on photography, print material and tradeshows. But there are now a plethora of online resources that let you do those things digitally! Sites like MadisonBuyer.com, FindFashionRep.com, RetailAGoGo. com, and TheFashionSpot.com allow designers to network with other industry

Macala Wright Lee

professionals and find creative resources to build their businesses and expand their product distribution online.

Madison Buyer is an online extension of a traditional tradeshow. The site allows retailers and buyers that can't attend every tradeshow to discover designers and brands online. The site is a platform for designers internationally to gain online exposure as well.

FindFashionRep.com allows designers to find a sales showroom or sales representative to carry their line in the markets they want to target.

RetailAGoGo.com offers online marketing and PR courses that teach you to grow your business until you are able to hire professional help.

To better educate yourself on the business of online retail, you can read Businessoffashion.com, Signature9.com or Fashionista.com.

DO YOUR OWN ONLINE PR BY BUILDING RELATIONSHIPS WITH BLOGGERS

These days, fashion designers have the luxury of going directly to the source for online reporting, editorial and trends — style bloggers. Bloggers are valuable allies for building awareness of your product line and gradually increasing online sales through the exposure they give you.

When working with bloggers, look for blogs in your target market that fit your target audience. If you're looking for fashion bloggers then conduct a simple Google or Twitter search to see who comes up. Ask your fellow designers

which blogs they read, join IndependentFashionBloggers.Org to learn about the world of fashion bloggers, or you can also check Signature9.com's top fashion bloggers to find bloggers that interest you. Some of my favourites are The-Coveted.com, GalaDarling.com, PRCouture.com, LoveMaegan.com, BleachBlack.com, Ecouterre.com and DesignSponge.com.

When you find a blogger you'd like to work with, respectfully contact him or her with why you like their work and what you'd propose to do with them; usually you'd provide product for him or her to review or use in photo shoots, or you could offer him or her some financial compensation for guest-writing for your site.

If you choose to use certain bloggers to feature your product, you will need to anticipate a ton of contacts from other bloggers requesting to review your product or partner with you in another way, such as a giveaway. Weigh these requests carefully; not all bloggers who contact you will fit your brand's goals. It's OK respectfully to say NO to certain requests. For information on blogger and brand relationships consult IndependentFashionBloggers.org, or indeed my site, FashionablyMarketing.Me, has tons of information on building mutually beneficial relationships.

Macala Wright Lee

Macala Wright is a digital-marketing and social-media consultant for fashion and beauty brands. She is the founder of Fashionably Digital, an online marketing firm in Los Angeles, California, and can be contacted at macala@fashionablymarketing.me.

People don't like to be sold,
but they love to buy.

JEFFREY GITOMER
ON SALES

CHAPTER FIVE
THE SALES PROCESS

How do you get your designs in the doors of your most desired retailers and boutiques? Should you find a sales rep or sell your own line? Let's go through some practical ideas on things like preparing for a tradeshow, presenting your collection and developing long-lasting relationships with buyers.

HOW TO SELL

One of the first decisions you'll have to make in the sales process is exactly how you want to sell. Do you want to sell directly to retailers or directly to consumers via the web or through your own retail store, or all of the above?

There are a few schools of thought here, but I typically recommend new designers start by selling wholesale to boutiques, which means you have to manage fewer customers but sell more units, taking advantage of the cheaper prices of producing in bulk. This means you are selling the product for a lower price (i.e. a wholesale price, usually about half of the same retail price). For example, you can sell 100 units to one buyer at a retail store completing one shipment and managing one relationship. But selling 100 units to 100 different consumers would mean 100 shipments and 100 different consumers to deal with. The time and administrative costs involved in dealing with individual consumers could end up being counterproductive to making a profit and moving your business forward.

Selling wholesale also allows you to build your brand with the help of other brands that already have a reputation. If you're able to sell to well-known boutiques you could instantly become a great brand name in customer's minds, based on the favourable association.

Finally, when you are selling wholesale you produce your goods based on orders. So although you may have some overruns, you don't have to have much product in advance of actually selling it, minimising the risk of tying up your cash producing goods that might not sell.

On the flip side, some designers prefer and have done very well with selling direct, staying away from retailers and what comes along with them, such as having to attend expensive tradeshows to attract them. As a result they can collect the full retail price as payment for their goods.

If you're not sure which route to take, operating under a hybrid model is a good compromise. Begin by focusing on wholesale accounts then pull in an online sales strategy to sell directly to customers, take advantage of high retail margins, clear items you didn't sell wholesale and get to know your customers better. Whatever you do, begin with one strategy or another. The biggest consideration should be how much you and your team can handle.

KEEP A LIST AND CHECK IT TWICE

During my initial consultation with new designers, one of the first things I tell them to do is to make a list. List all of the stores you want to sell to and organize it in an Excel spreadsheet. Gather any detail you can on the store including their address and any emails of buying contacts you can obtain by phone or through their websites. After you've exhausted the stores you can imagine yourself selling to, take a look at your competitors and the store locators on their websites and add those stores to your list. Keep this list running as you'll constantly be adding and maybe even subtracting stores throughout the lifetime of your business.

As much as you want to sell your goods, as you're building your brand you don't want to sell to just any place with a fluorescent 'Open' sign. You'll need to have a strategy. Start by pursuing the most notable stores on your list – those that

you may be able to use as leverage to sell to others. Smaller store buyers like to hear that you have been validated in some way by a boutique that they respect. If you can sell to the most well-known stores first, that will work as a selling point when selling to less prestigious boutiques.

Concentrate your budget on a list of 'top 10 I'd do anything to get into' stores and generate marketing initiatives focused on them. With one client I was providing marketing services for, we FedEx-ed press kits to her top 10 stores prior to her first tradeshow visit, and followed up by phone. Was this expensive? Of course it was, and it would have been a heck of a lot more expensive had we done it for everyone. However, she was able to sell to some stores she was dying to get into, which subsequently helped her sell to even more stores by 'name dropping' those she was already in.

SELLING TO BOUTIQUES

How do you get your fashion line in the doors of your must-get-into boutiques? You can either hire a sales rep who has relationships with stores you wish to sell to, or you can begin by pitching the collection to boutiques yourself. If it's not your personality to sell this may not be something you're keen on doing. However, it can be very beneficial to the launch of your line to start by being your own salesperson. Michael Cohen, owner of two multi-line showrooms in the New Mart apparel trade centre in Los Angeles, once told me he always tells designers to start selling themselves first to build their momentum, as launching in a showroom might put them at a disadvantage. The truth is, showrooms make the bulk of their profits from the commissions on the large sales of established lines. When they sell unknown designers they are typically selling in much smaller amounts and are not going to reap the same financial rewards. At least until the line builds its reputation, which could take years.

Once you've personally landed yourself in a couple of your top stores, this can give you the ammunition to get better sales representation because showrooms have some proof that your brand can be a serious contender in the marketplace.

TO SELL TO BOUTIQUES

RESEARCH THE RIGHT CONTACT

Attempt to sell your line to your top stores by giving the store a call to acquire the buyer's email or office telephone number. Also, if you frequent a particular boutique you may find an easy opening in which to ask one of the sales people during your visit. Some stores also have the buyer's information listed on their website.

WARM UP THE SALES CALL

Send your lookbook, line sheet and biography by mail or email before you initiate a personal sales contact. Attach a short personal cover letter, letting them know you'd be interested in making an appointment with them to show your collection at their store. Then follow up with a call.

MAKE AN APPOINTMENT OR SEND SALES SAMPLES

Enquire with the buyer or their assistant whether you can come in and show the line or send them sales samples (which must be returned to you of course).

You can also attend a tradeshow. This is something we will talk about later in the chapter.

WHAT BUYERS WANT

Store buyers are looking for items they know they can sell. They are not looking to be convinced or sold to. They know their store and their customer. They want to feel confident they can sell whatever they buy at full price for the majority of the season.

That is why before presenting or reaching out to buyers you want to do some heavy shopping research of your own. You want to get to know your top preferred potential retailers, so that you can be conscious of how exactly you fit inside their box. Do they normally buy a wide variety of jeans or just a couple of select brands? Which of your key competitors do they sell? How often do they get in new products? What is their average price point on your category? There is a lot you can learn just by browsing through the store or viewing their website.

TIPS FOR PREPARING YOUR MARKETING AND SALES PRESENTATION

1 *DON'T OVERWHELM BUYERS WITH TOO MANY CHOICES*
No one wants to feel confused about what to buy. It's your job to pick out the best you have to offer and present a tight-knit collection. Carefully edit and merchandise your collection so that no two styles or two colours within a style are too similar, making choosing easy and obvious.

2 *SHOW BUYERS YOU'LL HELP THEM SELL*
Communicate to buyers that you have PR and marketing efforts in place that will help lead customers to their stores. If you manage a store locator on your website, are investing in an ad campaign, or have just hired a publicist, let buyers know.

3

LET THEM KNOW YOU'RE THE REAL DEAL

In your marketing materials explain your background: if it is in manufacturing and design, allude to your manufacturing process or the staunch financial backing you have. Buyers are afraid that new companies might not be able to deliver on time. Show them that you can and you will.

GETTING REPRESENTED

A fashion sales rep helps you to find the right stores to sell your wares to, and also has relationships with buyers to help get you in the door. They may work independently by setting up at tradeshows and travelling to meet with buyers, and/or they may work within a showroom where buyers come to shop the same way you or I go shopping at the mall.

Reps take on specific markets such as women's contemporary, men's, kids, missy, plus size, accessories etc., which they should understand inside and out. They know the trends and should be able to advise you on pricing, your assortment, and even tactics for growing your business in their market.

Sales reps work primarily for commission (10–20%) depending on your category. For example, if the market for your goods is smaller, such as kids' clothing or accessories, you're probably looking at a higher commission than the women's ready-to-wear category, which offers more of a sales opportunity. In addition to a sales commission on the wholesale prices of everything sold, they're also likely to require a showroom fee (US$300–500 or more) as well as travel and tradeshow fees.

Unfortunately, taking on sales representation can be quite a drag on your bottom line. But if a seasoned sales rep, with their access, credibility and salesmanship, is able to open doors that would otherwise remain closed, it can be well worth the expense to put your brand on the fast track to growth.

WHAT MAKES A GOOD SALES REP?

The right sales rep for your brand will be on a first-name basis with buyers working for the types of stores you want to sell to. They should also currently rep lines that are compatible with yours but not directly competitive. For example, if you have a contemporary denim line they may also rep a contemporary T-shirt line and a contemporary active-wear line. They should not already rep a line that would be considered your direct competitor. If a buyer is working with your rep and looking for denim, you want the rep to be able to stand behind your collection to the fullest and not have to decide which line to side with.

From a personality perspective the rep you choose should not only be a stellar salesperson but also a good partner. A great salesperson can be another valuable business mind and a resource for the overall growth of your company. That said, they must believe in your line, be encouraging and feel like they can help you grow. In the beginning, as the sales rep revs up the growth of your line, they won't be making much money on commissions as they introduce your products to the marketplace. So if they aren't sincerely interested in working with you for the right reasons, they may let your clothes sit in their showroom for a few months to collect rent, without really making a serious attempt to sell your brand. Then after a few months of you paying them rent, you find they drop you, leaving you with a season of sales lost which could leave you in a very bad position.

GETTING EXCLUSIVE

Showrooms and sales reps will more than likely require that you sign an agreement giving them exclusive licence to sell your product in a certain territory, meaning part of the country or part of the world. They want the opportunity to sell your product to be wide open. They don't want to be in competition with another rep or

even with your personal sales efforts, for that matter. This is great if they go after stores full force and can sell your product within the season. It's not so great if they sit on your product, collect the rent from you or a base fee, and give you excuses as to why they weren't able to sell this season. And with that exclusive contract they signed with you, guess what – no one else has been selling either.

HELP SHOWROOMS HELP YOU

You can best support your showroom by producing blockbuster marketing materials such as a user-friendly website, easy-to-use line sheets with all the information needed to buy (and the showroom's contact information), postcards that can be sent out seasonally, and beautiful and quality product season after season.

You should also set goals for your showroom. Get them to tell you what to expect for the season. If they offer some loosey-goosey answer that is really code for 'don't have any expectations', find another place to work with. They need to be working to a set of projections they can show you, whether high or low, just so you both know what to expect and you know what you need to prepare for. After all, you have a big investment in your line, and if you're going to hand it over to them in any kind of exclusive way they need to be able to tell you from a units and dollars perspective what type of sales they anticipate. If they have nothing to say, look elsewhere. You have too much at stake.

HOW TO FIND A SHOWROOM

Finding the perfect showroom is like finding the perfect man or woman. It's far from easy, and most are far from perfect. Talk seriously to at least three qualified

showrooms before making a decision. In Los Angeles you can visit The Intersection, which includes four showroom buildings that represent thousands and thousands of lines. These buildings include the Cooper Building, New Mart, the Gerry Building and California Market Center. Find out more at www.fashiondistrict.org. In London you'll find some multi-label showrooms and fashion development agencies that will help with everything from marketing to sales and invoices, like Fin (www.finshowroom.com), RSR London (www.rsrlondon.com), Showroom (www.atshowroom.com) and Scout (www.scoutforfashion.com). New designers can start by checking Fashion Capital (www.fashioncapital.co.uk), a leading UK fashion business portal, or The British Fashion Council (www.britishfashioncouncil.com), which has an international design initiative called London Show Rooms that helps designers showcase their wares in London, Paris and New York. The Centre for Fashion Enterprise, a business incubator for new designers, is another option. All of these organizations have resources that can point you in the right direction.

In New York you'll find showrooms all around the city in neighbourhoods ranging from Bryant Park to Soho to the Meatpacking District. Check the websites of comparable lines to yours and see which showrooms represent them. Call the showroom and ask if they are looking for new lines. If they are, send them your marketing kit and follow up by phone.

You can also meet reps when you present your line at a trade event. If they see you are doing well without their help, they will recognize your potential and ask to work with you. Travel and visit showrooms in person. Many of the larger showrooms also have sister showrooms or international affiliates. So if you find a rep in one city and they don't have relationships or distribution access around the globe, they can often refer you to partners in other cities to broaden your reach.

THE FIRST MEETING: ROMANCING A SALES REP

In your first meeting with a potential sales rep, make every effort to put your best foot forward. If you even think you want them, sell yourself and your new company like nobody's business.

Start the meeting by showing the rep your final sales samples and marketing materials, and by sharing the long-term vision of your company. Reps love to see that you have a long-term vision and a plan to get there. You want to vividly display the passion and commitment you have for making your business grow.

Also highlight stores you've gotten into without a showroom – yes, you should be trying to get yourself in at least a few brand-building stores before taking on a showroom. You should also show them press coverage you may have received, and mention investors so they understand your business is secure. Also, don't forget to bring up your past work experience to give them some insight into your competence as a businessperson. Don't be shy, now is the time to toot your own horn. But make sure you do it in good taste; if you seem arrogant or annoying they may sacrifice repping the line just to avoid dealing with someone they don't like.

Once you have them where you want them – meaning they are thrilled about the prospect of working with you – it's time to start negotiating things like commission percentage, rent fees and the term of your agreement.

The better you present yourself, the more flexible the showroom will become. Give them reason to believe they have much more to gain than to lose by taking you under their sales umbrella. Even though showrooms tend to have a bit of a snob appeal, at the end of the day they are in the sales business and need you as much as you need them.

If you present a marketable product, a great strategy, a strong business acumen and a likeable personality, the idea of carrying your line can quickly go from getting a straight 'No!' to a no-brainer.

TIP

Don't forget to ask the right questions to make sure the showroom you're talking to is going to be the best one for your brand. Enquire about who else they represent, whether they have client references you can call and how much they've sold of a line similar to yours in its first season.

TRADESHOWS

Fashion tradeshows kick off the beginning of every sales season and are a very concentrated marketplace for buyers and sellers to meet. Tradeshows may focus on a specific category such as a bridal, kids, contemporary or action sportswear. They could also be more general events like Magic International or Pure London, which have a subset of different categories within the same event.

It's always good to go to trade events, whether you are officially participating or not, as you'll also have the opportunity to casually interact with suppliers, contractors, apparel technology companies, financiers and other industry players who could be useful to you now or in the future. Retail buyers mainly come to connect with some of the existing lines they carry and view the latest collection and maybe even check out some new lines. However, most of the time larger tradeshows are appointment-based. A spokesperson for Magic International, a leader in the fashion tradeshow industry, says their trade events are about 90% appointment-based.

There are certain smaller shows focused on emerging designers that are more open marketplaces where buyers may be more inclined to browse new brands, such as Designers & Agents or the Margin show in London. You can get a schedule of popular tradeshows on weconnectfashion.com (as well as right here in the back of this book) to find shows in your category. Once you've identified some possible

shows, review their websites to see if exhibitors there have similar brand values to your own.

Also, get friendly with some boutique buyers at shops you frequent, ask them what shows they travel to, and investigate if those shows might be a good fit for your brand. If you're working with a showroom, they will already have shows they attend for their existing lines and add your collection to their multi-line booth.

DECIDING TO SHOW

- -

Tradeshows are expensive. Besides the expense of travelling to a show, a tradeshow booth can cost thousands of dollars to build and transport, and then there are also the exhibition fees, which are usually in the thousands of dollars.

Before you commit to attending a tradeshow do your own due diligence. Call the show's office and request more information on attendance patterns, who attends what (i.e. specific press, retailers and other vendors), how much of the show is appointment-based as opposed to walk-by traffic, and how they can help you secure appointments as well as market your brand during the show. They may be able to give you lists of contact information on attendees and the press; or have a directory where you can place an ad; or host a fashion show in which you can participate during the trade event. These added-value elements can help you further market your brand and make the show worth your while.

TRADESHOW MARKETING STRATEGY

Many shows are appointment based and you'll need to do some marketing in advance to secure appointments and drive traffic to your booth. Here's how...

REACH OUT

Before you go to a show, you have to do some outreach to stores and press that will also be at the show, so that you can take full advantage of the opportunity in front of you. Start by sending out mailings to stores that you believe would be

at the type of show you're exhibiting at. In many cases the shows can offer you a list of past attendee buyers and press that you can send things to. If they can't provide a list, you can do a general mailing, based on your research, to stores likely to come to the show.

Send your prospects postcards or emails showcasing your upcoming season. Follow up by phone and make every attempt to secure an appointment.

SELL FAST

Once you have drawn buyers into your booth, you only have a short time to sell to them. Keep in mind that a tradeshow can be quite an overwhelming experience for a buyer. They've trolled around to booth after booth, speaking to countless sellers. It's not a normal sales experience where you may have someone's undivided attention. They've been travelling, they are distracted and tired, and they don't have a lot of time, so you must be quick to jump to the point and engage them with what you've got to offer.

First, you'll want to find a tactful way of screening them quickly, diving right in to find out what their store is like to see if it's a fit. If you've never heard of the store, ask for the buyer's card and employ some pointed small talk to find out more about their most popular brands. This will help you determine if they will be a respectable match for your company.

Once you've screened them you're ready to start giving them an overview of your line – highlighting your key styles and bestsellers (if you have any yet). It's important to tell a compelling story about your company. Whether it's your background in the industry or the materials you're using, plant a seed in the buyer's head so they know you're not some Joe Shmo that just woke up one day and threw a collection together. Finally, give them your marketing kit to take away, and don't forget to jot down any notes on your interaction on the back of their card that you can use in your follow up process.

SEAL THE DEAL

After the show is over it's time for you to get busy sealing the deal. Most buyers have to go back to their stores or offices and make decisions – they won't just write out an order on the spot. You should plan on re-sending a marketing kit to your priority stores, with a personalized note detailing some of their selections and key order-by dates.

For lower-priority stores or for everyone you've seen that you may be interested in, send them a follow-up postcard with a handwritten note highlighting something about the experience or conversation you had with them. Personalize it to make it stand out. Exclusive store buyers want to believe you want nothing more than to sell to them specifically, not just anyone willing to buy.

The bottom line is no matter how much a buyer might like to spend, they may be limited by budget constraints or waiting for you to build some more name recognition so that buying your product is less of a risk. Market research suggests that a buyer may need to see a marketing message up to seven times before making a purchase decision. Don't forget, building your business is a marathon, not a sprint.

TIP

Buyers are suspicious of new lines. They are petrified you won't deliver on time or that your product will be substandard. Take every opportunity to show them just how professional you are, from your stellar marketing materials to your friendly outgoing message. Make it clear that no detail is exempt from your personal touch.

NO SHOW, NO PROBLEM

--

Tradeshows can be wonderful because they plant you in a concentrated environment of people looking to buy products in your category. However, they are not absolutely necessary to sell your line. You or your sales rep can still travel to the show area during the time it is happening, and use non-traditional avenues to sell.

For example, during London Fashion week many designers set up installations in Somerset House, which hosts the official Fashion Week event, or at nearby boutique hotel rooms in central London. You'll still have to do your marketing outreach before the event takes place and work hard to set appointments. If you're setting up a makeshift booth at a hotel, see if you can join forces with other emerging designers so that you can combine your marketing resources to draw people to your location. Although your space may be super-close to the show site, you'll still have to bear in mind that you're asking tired buyers, who may already have travelled a long way just to attend the show, to leave it and find their way to you. For this you'll need to create a pretty compelling offer to take them off the beaten path. You may want to market your showing as a morning sales brunch before the show or an evening event with wine and cheese to make it a more relaxing environment at the end of a long day.

LET GO MY EGO

--

If you are doing your own sales it is hard not take unfavorable responses personally. If it has taken you months of hard work, it has to be painful to hear a buyer call the puff sleeves you spent countless hours perfecting 'dated' or 'way too much'. Sometimes buyers even feel awkward telling someone they know is the designer

> ### *The complaining customer represents a huge opportunity for more business.*

ZIG ZIGLAR
ON FEEDBACK

how they really feel about the line. Although steering clear of negative feedback is good for saving your mascara from flaking off when you burst into tears, it's not so good from the perspective of growing your company.

When you are in the middle of the design process, it is easy to be so focused and attached that you lose sight of things that may be imperative to your potential consumers. When you decide to sell your own product or participate in the sales process alongside a sales rep, leave your ego at the door. Take a pain pill in advance and solicit, encourage and write down any feedback you get from potential buyers that could help your business improve.

SELLING ON CONSIGNMENT

Consignment means you're providing your product to retailers and then splitting the proceeds when the product is sold. This situation can work but it can also be a little scary since the retailer is not sharing the investment in your products. Although the retailer will get paid once the product is sold, if they don't sell it they have no obligation. By contrast, if the products they've purchased outright don't sell, they've lost money. Therefore the products the store actually owns may get better placement in the store as well as more sales support from the salespeople,

putting you in a lose–lose situation. Your inventory spends ages on their shelves only to get returned to you at the end of the season.

On the bright side, if the store is one that you think would offer a great advantage to you because it is a high-traffic store in a chic neighbourhood, giving your brand much-needed exposure to your target market, or you have inventory on hand that you need to sell, consignment could be a useful option.

If you go the consignment route, be sure you have the complete terms outlined in writing with your retailer, including an agreed-upon percentage split of the profits; who assumes liability for damaged and/or stolen products (they should); as well as presentation standards, pricing and markdown options. You'll also want the agreement to be such that you can collect your goods or the retailer can return them at any time. If the retailer wants to return, it means they are no longer committed to selling them, so you might as well have your product back under your own control. Also, if you need the product to sell to another vendor or no longer want it placed in the store for whatever reason, you can simply go and pick it up.

SELLING TO MAJOR STORES

'Most new companies will not make it in department stores,' apparel consultant Laury Ostrow definitively says. While he admits there are always going to be some companies that rise to the top, Laury says in his experience, those companies are few and far between.

Selling to department stores, which are commonly known as majors, is a key goal for most brands, but it is not easy. For starters, you must comply with some pretty hardcore guidelines, including having a program for retailers to electronically order your products (commonly known as EDI) in addition to adhering to some stringent conditions on how you ship your products, how much your wares will be

discounted and when the store will pay. Department stores are also infamous for chargebacks, i.e. imposing discounts on the basis that the product was not shipped, packaged or tagged as the department store outlined in its conditions. This could include putting a tag in the wrong place on the garment or a shipping sticker on the wrong side of the box, or leaving a line out of the address.

Simple mistakes could cost you big bucks, or cause the store to completely reject the order, leaving you to pay for the cost of producing the goods. If you're just learning the business you will certainly be capable of making some simple mistakes, which makes it risky to work with department stores even if you get the opportunity. Get your training wheels off first before attempting to play with the big boys.

SELLING DIRECT

You may decide to forgo tradeshows and in-store presentations with buyers by selling directly to the consumer via your own storefront or online store.

To do this, in addition to manufacturing you'll have to set up a retail business structure that caters to the needs of individual consumers. Selling direct means you can take advantage of retail margins by cutting out the middleman retailer. You can also get to know your customer and receive direct feedback from them as you grow your business.

You may sell direct as a main strategy or use it as a supplementary strategy to clear leftover inventory. However, setting up your own retail store requires many different components, most of which lie beyond the scope of this book. However, here are some important tips for executing a direct sales strategy online.

TIPS FOR DIRECT ONLINE SALES

1

MINIMIZE YOUR ASSORTMENT

Keep your colours, sizes and styles to a minimum. When producing inventory in advance there's no sure way to know if someone will want a shirt in a blue size 6 or red size 8. Where possible limit your range of offerings in order to meet production minimums. Try to pare down size ranges as well, sticking to small, medium and large as opposed to a wide range of numerical sizes.

2

GET YOUR CUSTOMERS TALKING

One of the main advantages of selling direct is that you avoid the filter of a 3rd-party retailer and get to stay close to the customer. Employ tactics such as customer-service follow-up calls, surveys, blogging, an area on your site soliciting feedback, or website analytics such as the free Google analytics tools, to learn more about your buyers and what they want.

3

PLAY FAIR

If you're selling online as well as to boutiques, put a manufacturer's suggested retail price on your goods. That will set the expectation with your retailer buyers as to what markup they can expect from other retailers, including you. You never want to appear as if you're competing with your retailers by selling products on your site at a lower price than they are.

A FEW WORDS OF ADVICE

from designer and entrepreneur Cynthia Vincent

Cynthia Vincent

Cynthia Vincent started her first company, St. Vincent, in 1993, then in 2003 launched her celebrity-favourite 12th Street by Cynthia Vincent brand, named after the street where she grew up. Cynthia Vincent collections are sold at Barneys New York, Saks Fifth Avenue, and over 500 speciality stores across the US as well as selected stores in Dubai, Japan and Europe. Cynthia sat down with us in her Los Angeles offices to share her advice to aspiring fashion entrepreneurs.

CYNTHIA ON ENTREPRENEURSHIP

Having worked for other people then starting my first company St. Vincent, the freedom was so liberating. I thought, 'Wait a minute, I don't have to be anywhere I don't want to be. I can be creative and not dictated to.' I didn't have to adhere to someone else's ideas and that was very pleasant.

CYNTHIA ON PARTNERSHIPS

You need a partner who can run the other part of the business – someone strong in sales, production and finance. If you try to do it all alone, the creative side suffers. It's hard to buy that amazing roll of fabric that's 60 dollars a yard if you know you may be late on payroll.

CYNTHIA ON GAINING EXPERIENCE

I worked for many years at other fashion houses and take a strong stance on gaining experience with other companies before going out on your own. My advice to new designers would be to get experience working for other people. I'd say a minimum of five years, but some others would say ten.

CYNTHIA ON FASHION SCHOOLS

I don't think it's necessary to go to fashion school, but it is always advisable to get an education. It allows you to know the basics you'll need in order to communicate with your team. I've worked with a lot of designers who didn't go to fashion school and have struggled to convey their ideas.

CYNTHIA ON EMPLOYEES

My first hire was a bookkeeper who came in two half-days per week to take care of finances. I also hired a sewer and cutter from another company who would come in after hours to cut and sew my line. To determine who to hire for something you can do yourself, think about your time and how valuable it is and If it's worth it to pay someone or better to do it yourself.

ON SALES REPS

The first time I got a rep she knew me and believed in me. Put yourself out there. There are a lot of sales people, so it's really about finding the right fit.

ON THE INDUSTRY

It's tough. I wouldn't wish this industry on my worst enemy. But for me, there is nothing else I'd rather do.

PRODUCTION

CHAPTER SIX
PRODUCTION

You've received your first batch of orders. Now where in the world do you produce? Locally? Overseas? How do you find a factory? How do you avoid getting ripped off and ensure you get treated with respect despite your limited knowledge in the industry? Garment production is no easy feat, but we'll show you how to avoid some of the major pitfalls that can stop new designers in their tracks.

WHAT DID YOU CALL ME... A MANUFACTURER?

I know, 'manufacturer' is not a sexy word. A manufacturer could mean someone who actually makes garments themselves or it could mean someone who simply facilitates making garments. Check with government and local agencies to see what would classify you as a manufacturer and what licences you will need to handle manufacturing in your area. If you are producing products for children or babies, in most places you are also required to get your products tested and approved before they can be sold in the marketplace. If you or your contractors do not have the proper licences, it could mean that your products get seized and you get heavy fines.

ORGANIZING YOUR PRODUCTION

When you are making products based on an order from a retailer, it's crucial to keep your delivery deadline. What's the big deal? Well, the usual suspect — money. Buyers operate from what's referred to as their open-to-buy plan or budget, where

Calendar

JANUARY

						1
2	3	4	5	6	7	8
9	10	11	12	13	14	★ 15 trade event
16	17	18	19	20	21	22
23	24	25	26	27	28	29
30	31					

FEBRUARY

		1	2	3	4	5
6	7	8 ✿ final order	9 ✿ tally orders + quantities !	10 ✿ order fabric order buttons/ trims	11	12
13	14				18	19
20	21	22	23	24	25	26
27	28 ✿ receive fabric ✓					

MARCH

		1	2	3 ✿ receive trims ✓	4	5
6	7	8	9	10	11	12
13	14	15 ✿ production begins	16	17	18	19
20	21	22	23	24	25	26
27	28	29	30	31 ✿ production complete ✓	1	2

APRIL

| 3 ★ finishing / packaging delivery / shipment | 4 | 5 ✿ quality review complete | 6 | 7 | 8 | 9 |
| 10 | 11 | 12 | 13 | | | |

the store has allocated a certain amount of dollars to buy products for a given season. Allocating dollars to your line means not being able to allocate those same dollars to another brand that could have delivered when they were expected to and allowed the retailer actually to sell the product when they'd planned to.

To avoid being late you'll need to map out a calendar working backwards from your delivery date to the date when you need to do a quality review of your product prior to shipping; then further back to your production date; then back again to the date when all your materials will be needed for production; and finally back to the date when all your materials will need to be ordered for production.

Even before you finalize the materials you'll use for your products, enquire with the vendor about how long you will have to wait to receive your bulk order once you place one. Do they have those materials in stock for a quick one- or two-day turnaround, or are they custom materials that have to be made to order or shipped from overseas, a process which could take weeks or even months?

Be clear about timing and scheduling with your factories. Make sure you know how far in advance you need to schedule production and how long the process takes once production is scheduled. Plan all these dates on one large calendar so you're able to make delivery promises you can actually keep.

GOING LOCAL

With more retailers wanting to buy closer to when a season begins, producing locally allows you to be hands-on with your production and turn your product around quickly. While shipping your concepts off to China or India can look on the surface to be a lot less expensive, basing production so far away from your physical location doesn't give you ongoing visibility of your goods. It also limits the education you get from nurturing your products through the manufacturing

process yourself; understanding how your product is made may enable you to improve it.

Jana Blechová, a production specialist from the garment production company Attias Group, urges new fashion entrepreneurs to avoid the complexities and time delays of offshore manufacturing, keeping their production close to home and managing it themselves. 'It's easier to sit with the person who did your pattern in order to make corrections. If you're sending things to China, it's going to take a while. Staying local and managing your own production is a healthy process for growth,' she says.

By doing business close to home, you'll be able to check in on production and work out kinks which, if you were to discover them only when the production run returned from overseas, could make you late for your deliveries. You'll also have flexibility to pull your production and shift manufacturers if your products are not coming out to your specifications.

Alas, it always helps to develop strong relationships with the people who produce your products. A by-product of these relationships should be the manufacturers providing you with an education, enlarging your understanding of the whole process. To foster these relationships and to be involved in the management of your production, make finding a local production house close to home a top priority.

USING A ONE-STOP SHOP

Using a one-stop shop for production can be an option for a new company as long as the price is right. These companies can do everything from design and sourcing your materials to producing and shipping mass quantities of your products.

How a one-stop shop generally works:

1 You visit the company with a sample that indicates the type of fit you are looking for in your own products. You may also show them other samples and visuals to communicate how you'd like to make the product your own.

2 The company comes back to you and shows you material options for producing your products: fabrics, yarns, buttons, linings etc. They review the costs with you and advise you on the best choice to meet your goals.

3 The company makes samples and reviews them with you for approval.

4 Once you get orders they produce the mass quantities.

The good thing about one stop shops is that they can usually do smaller production runs, which makes production more cost-effective for new companies.

A FEW WORDS OF ADVICE

on manufacturing by Laury Ostrow, Apparel Manufacturing Consultant and Entrepreneur

San Francisco-based SJ Manufacturing has made products for companies such as Nike, Levi's and L.L. Bean. They have also helped everyday people transform their fashion aspirations into thriving businesses. One of the company's principals, Laury Ostrow, answers some of the questions most frequently asked by new fashion entrepreneurs.

WHAT IS THE BEST WAY TO START A CLOTHING LINE?

Start with one product. This way you can get to know your customers and expand from there. This product should be something you are personally passionate about. You must be your own customer. There has to be a compelling reason why you would go out and buy the product you intend to sell.

WHAT ADVICE DO YOU HAVE FOR NEW COMPANIES ON POSITIONING THEIR BRANDS IN THE MARKETPLACE?

Definitely start at the high end. As a start-up your costs are going to be a lot higher. You'll do better financially doing less at a higher price than more at a lower price. We normally try to get our clients to think higher than their original plan.

HOW LONG DOES IT TAKE TO DEVELOP PRODUCTS?

The longest part of the process is sourcing the fabric you want to use. Once fabric is secured it normally takes us about three weeks to create samples and set up production. If you're not local, of course, you'll have to work shipping times into the equation.

HOW MUCH SHOULD A COMPANY EXPECT TO SPEND TO MAKE THEIR PRODUCTS?

Using jeans as an example, at our company we can produce 100 high-quality pairs of jeans for you from start to finish for about USD$4,000. Having this small production will allow you to introduce your products to the marketplace and get to know your customer. In order to make a profit, look at the costs of your first few production runs as a start-up cost, not the cost you'll mark up from. As your quantities go up, your costs will go down.

WHAT DO YOU THINK ABOUT OFFSHORE MANUFACTURING?

Most new companies are not prepared to go offshore. When you produce offshore you need to have representation in the country where you are producing. We hear a lot of nightmare stories of people working with offshore factories. If someone really wants to do that we can show them how, but you really need to have some representation in the country to do it well.

You can visit Laury's website to learn more about the garment production process at www.sjprivatelabel.com.

Laury Ostrow

COMMUNICATION IS KEY

When managing your production, excellent communication is going to be paramount. In the beginning stages, even the slightest miscommunication about how something is to be cut or sewn or assembled can throw your entire business out of kilter. Seriously.

Never allow your contractors to nod their head as a confirmation that they understand what you want. Make a habit of writing things down not only for yourself but for the companies that are producing your goods. Send emails then follow up by phone and send another email about what you talked about by phone just for clarification. Create detailed visuals whenever possible, and keep copies for your own reference. It may seem like you're doing too much, but you don't want to give people room to make any assumption about what you expect.

THE TECH PACK

Have you ever gone to a restaurant, given the waitress your order, watched them write it down and nod their heads in full agreement to all your 'light on this and none of that' exceptions to the menu only to come back with the wrong order? It happens. People aren't perfect. But your business is not a $25 dollar dinner; there's a lot more at stake. You cannot afford for the waiter, in this case your contractor or factory, to come back with the wrong order. This could disrupt the timing of your upcoming deliveries, resulting in lost orders, lost dollars and a tarnished reputation. It could also lead to a dispute between you and your contractor that could quickly lead to legal fees or bad blood.

Either way, as the business owner you must control any communication relating to production. An easy way to do this is by creating a technical pack,

also known as a tech pack. A tech pack is a clear, concise and effective way to communicate all the technical details of your products, dictating exactly how you want your goods to be produced. It may include elements such as a technical sketch, a swatch of the exact fabric, thread, measurements, the cut of the fabric, the buttons, the zippers, the stiffness or fusing of the collar, the inside label. This tech pack can serve as a contract of sorts between you and your contractor. It is important before going into production to have a discussion about each of your styles and to clarify any notes on the tech pack.

THE COST EQUATION

According to an industry rule of thumb, commonly referred to as a keystone markup, you should be able to mark up by at least 120% of your wholesale price and expect your retailers to raise it by at least the same percentage to obtain a retail price. The keystone markup is used as a baseline to determine whether a company is being profitable or not.

A KEYSTONE MARKUP EXAMPLE
$20 (your cost) x 2.2= $44 wholesale price
$44 (wholesale price) x 2.2= $97 retail price

In the example above if the product can't sell for at least $97 the producer needs to find a way to lower their costs in order to be profitable. You can also work the other end of the equation and try to make your product appear more valuable by repositioning it in the marketplace.

Tech-Pack

STYLE NO. LF10023
DEEP V SWEATSHIRT

MEASUREMENTS

A	**OAL BODY LENGTH FROM HPS:**	27"
B	**BUST (1" BELOW ARMHOLE):**	19"
C	**WAIST:**	18"
D	**BOTTOM SWEEP:** relaxed rib	16"
E	**ACROSS FRONT (6" FROM NATURAL HPS).**	11½"
F	**ACROSS BACK:**	12½"
G	**SLEEVE LENGTH:** from shoulder	29"
H	**SLEEVE OPENING:** relaxed rib	3½"
I	**ARMHOLE:** front raglan: 8" back raglan: 10½"	♣♣♥
J	**INSIDE NECK OPENING (EDGE TO EDGE):**	7"
K	**SHOULDER WIDTH:** raglan – meas at neck	5½"
L	**FRONT NECK DROP (FROM HPS–EDGE):**	10"
M	**BACK NECK DROP (FROM HPS–EDGE):**	1"
N	**BICEP: (1" BELOW ARMHOLE):**	7"

NOTES

- NO TOPSTITCHING
- EDGE STITCH: CENTER BACK NECK HALF MOON
- RIB: USF DTM 1X1 RIB FROM NECK TRIM, SLEEVE HEM AND BOTTOM HEM
- NECK TRIM IS 5/8" WIDE

FABRIC
1) LOOP TERRY– SELF
2) 1X1 RIB – NECK TRIM, SLEEVE HEM & BOTTOM HEM

TRIMS:
1) MAIN LABEL = GOLD DAMASK
2) SIZE LABEL = GOLD DAMASK
3) CARE LABEL

FRONT

BACK

COSTING

COSTING 101
FABRIC $4.00
TRIMS: $1.00
CUT & SEW: $2.00
SALES & OVERHEAD: $3.00
TOTAL PRODUCTION COST: $10.00

CALCULATING WHOLESALE PRICE
PRODUCTION COST: $10.00

MARKUP: 2.2

WHOLESALE PRICE:
$10x2.2=$22.00

CALCULATING RETAIL PRICE
WHOLESALE PRICE: $22

MARKUP: 2.2

SUGGESTED RETAIL PRICE:
$22x2.2=$48.50

Style	Fabric	Buttons	Label	Hang tag	Finishing	Cut and Sew	Total Cost	Wholesale Mark-up	Wholesale Price	Retail Mark-up	Retail Price
Shirt 1	4.00	2.00	1.00	1.00	0.10	5.00	13.10	2.2	28.82	2.2	63.40
Shirt 2	2.00	1.00	1.00	1.00	0.10	4.00	9.10	2.2	20.02	2.2	44.04

To calculate your cost, include everything it will take to make your product:

- Fabric
- Trims (buttons, zippers, grommets)
- Cutting and sewing
- Elastic and fusing
- Hang tags
- Special dyeing and washing treatments
- Finishing
- Packaging
- Shipping

Don't get scared off by high costs in your first few seasons. You'll be producing less and understandably your costs are going to be higher with smaller quantities. Enquire with your vendors about production costs and the quantities you'll need to produce in order to reap the benefits. If these costs still pan out too high, look to source less expensive materials.

Create an Excel spreadsheet like the one above to total your costs and calculate wholesale and retail prices.

> *The essence of a successful business is really quite simple. It's your ability to offer a product or service that people will pay for at a price sufficiently above your costs, ideally three, or four, or five times your cost, thereby giving you a profit that enables you to buy and to offer more products and services.*

BRIAN TRACY
*MOTIVATIONAL SPEAKER
ON MAKING MONEY*

MADE TO MEASURE

- -

In your tech pack you must specify to the factory the exact measurements of each size for each individual product. The factory may also give you an idea of the tolerance, meaning how far from the measurements a product may be in order not to be considered defective. In fashion, obviously fit is extremely important. Being 6mm (¼in) out on an armhole can seem insignificant on paper but may make the difference between a consumer buying your product or choosing not to. It's up to you to make sure the goods you receive are made to your exact specifications and that any tolerance you allow does not make a noticeable difference to the finished product.

NOT GOOD ENOUGH: QUALITY-CONTROL ISSUES

- -

After all the work you've put in, when you first get your products back from the factory you'll be elated to finally have them – indeed, so elated you might just forget to inspect all the little details. So before packing up your products and sending them off to stores, make it a part of your process to do a detailed quality inspection on your factory's work. Make sure your final pieces are as close as possible to the sample that was shown to buyers when it was first sold. Measure your products and examine them closely for defects such as holes, loose buttons or non-functioning zips. You build credibility and trust in your brand by going the extra mile to ensure quality.

EXTRA ... EXTRA...

If you're in the business of selling directly to retailers you should only produce products once a buyer has agreed to purchase them. While it's good to pad your order by a few pieces up to about 3–5% extra, speculating on what could sell might just leave you with a garage full of old clothes.

The only exception when it might be beneficial to order more than 5% excess inventory is if you have very minimal sizes and colours, for example, five varieties of one-size-fits-all tee shirts in two colours. The smaller the assortment the better your chance of guesstimating the size and colour selection that will be most popular. However, when it comes to a larger collection with a wider variety of sizes and colours to choose from, since you're a newbie without a lot of history you don't yet know how your sales might play out on a per product basis. Fashion inventory is like fresh fruit: it's perishable. Anything you decide to produce without a confirmed purchaser should be carefully considered.

FACTORING: MONEY IN THE MEANTIME

Since you're producing based on an order and won't get paid until you've shipped that order, you'll need some money to produce your goods before the cheque comes in. Factoring companies help solve this issue. Factoring is also known as bridge financing, accounts-receivable financing or asset financing.

It works like this: after you've sold your products and are ready to produce them, a factor essentially buys your invoices from you. This could cost up to 18–20% of your invoice. Yes, another huge bite out of your profit margin, but factors are a tremendous asset for many fashion companies. Instead of you running around hoping your stores will pay you on time, the factoring company will handle your payment collection. Since factors work with many different lines, they have

power in numbers to collect payment. A retailer certainly doesn't want to be left out in the cold when it comes to stocking their stores, and the big factors will blacklist the retailer from all the companies they represent if they pay late or don't pay at all.

A major advantage of working with a factor is that it gives your business the cash flow to handle other business needs like meeting payroll or preparing for your next trade event while you are making products for the current season. Factoring allows you to take on larger orders that you may not have been able to produce otherwise. It is also better than taking out a traditional loan as it does not affect the business owner's business credit or personal credit. Many designers owe the success of their business to having a fabulous factor.

The disadvantages begin with the hefty fee: 18–20%. When you match this up against showroom fees and the actual costs of your goods, you may decide that factoring is out of the question if you want to make a profit. Also, factors will often want to take control of *all* your invoices, so though you may be happy to collect payment from some stores, the factor will want exclusive rights to all of them, which could result in a sizeable business expense.

It is possible to be factored in your first season if you need it. Factors will evaluate your viability as a client, starting with making sure you have a good profit margin on your products. They'll want to make sure you have enough of a margin for them to collect their funds and for you to make a profit as well. They will look at the stores you've received orders from and if they are creditworthy, as well as your own previous experience in the industry, to evaluate if they'd like to work with you.

Start reaching out to factors before you enter into production to understand their way of operating and their requirements, so that you're prepared when the time comes.

PERSONAL FINANCING

Many designers have also financed their production on personal or business credit cards, in order to keep things moving until they get paid for their orders. If you want to do this, you'll need to have credit cards that you can use and then quickly pay off once you receive payment, to avoid paying excessive interest. Make timely payments on your cards and ask your creditors for periodic credit line extensions that you may need to use if you secure a big order. When financing yourself in this way it is more improtant than ever to insist on cash on delivery from your customers as having to wait another 30, 60 or 90 days to recieve your payment could eat up your profits with high credit card interest rates.

FINISHING TOUCHES

You know how you go to the store and buy a poplin shirt and it's just wonderfully crisp – complete with a 'new shirt' smell and feel. Many companies use professional finishing services to give their products that 'brand new' touch.

Finishing services include things like steaming or pressing garments, a quality review, cutting loose threads, adding hangtags and placing products in a polybag or on a hanger. Unless your factory has finishing services, when you receive shipments from them your products will require that extra t.l.c. before they hit store shelves. You can take the time to do it internally or outsource this process. These services are generally charged on a per piece basis depending on the treatment. Don't forget to add them into your cost calculation.

FIVE TIPS FOR SUCCESSFUL PRODUCTION

Garment Production Tips from Thelma Siguenza, Owner, Garment Solutions Production Company, Los Angeles, CA.

1 OVERCOMMUNICATE

Create tech packs for your factory, and follow up with phone calls and emails. Get things in writing whenever possible.

2 GIVE YOURSELF TIME

After you've sourced your materials, gather timelines from each of your vendors and pad them as much as possible to account for inevitable mishaps.

3 GET ORGANIZED

Production is all about detail and organization. Create a central production calendar working backwards to your delivery dates. Keep separate files on each of your styles including supplier names, materials needed and costs.

4 HAVE EVERYTHING IN WRITING

Have a contract that includes specifics on when the factory is going to deliver, and include a penalty for late delivery. If there is a delay, you can penalize them by the garment per day – for example, 25 cents per garment per day.

5 NEVER BURN BRIDGES

You never know when you'll get in a bind with production and have to go crawling back to a factory. It happens all the time.

Thelma Siguenza

Management is nothing more than motivating other people.

LEE IACOCCA
ON MANAGEMENT

CHAPTER SEVEN
MANAGING YOUR BUSINESS

MANAGING YOUR BUSINESS

We couldn't possibly end this book without reviewing important day-to-day management topics such as customer service and infrastructure development. Planning ahead on these not-always-fun matters will help you avoid the repercussions of common yet preventable rookie mistakes.

THE THREE-RING CIRCUS

- -

Things really get busy when you approach your second season. You'll have sold from your first collection and begun managing its mass production. You'll also be in the process of developing a collection for the upcoming season, managing the same process that you have already been through: creating a sample line, refreshing your marketing materials and preparing for a trade show or other sales presentations.

While your particular category may have several seasonal updates, as a new line you may choose to focus on the two main seasonal shifts, spring and fall, and mapping out multiple deliveries within these two major seasons.

Once you get past your launch you'll always be in motion, with little time to just sit down and think. This is why before you even get started on the obstacle course that is running a business, you need to have your business plan in place and always accessible for reference. Being organized and having processes already established is going to be key not only for setting up your business but for staying in business.

DEVELOPING A TRUMP-TIGHT INFRASTRUCTURE

- -

Your infrastructure refers to the inner workings of your business – your foundation. It includes your employees, your factories, your vendors, your systems of transportation and communication, and how they all work together for the success of your business. In the first few years, of course, you'll be working out some kinks as you get the hang of things and even after that, re-defining your infrastructure to fit the growth of your business will be an ongoing process.

As the owner you must continuously evaluate how you'll deliver a positive customer experience to your mass retailers and consumers.

WRITING IN FINE PRINT: TERMS AND CONDITIONS

There is something about fine print always seems a little tricky, as if someone somewhere is hoping you'll overlook something important so they can use it against you later.

Terms and conditions, such as how much time you'll allow someone to cancel an order, late-payment fees and indemnifying your business from being liable for extraneous cost on late deliveries, are a must. If you're working with a showroom, they may have standard terms you can alter to match your needs. If not, you can purchase templates for sale agreements on legalzoom.com or nolo.com and alter them to meet your requirements.

Make an effort to be upfront with your customers. After all, the goal is to build long term relationships with them. Translate any legal-ese into plain language to help ensure you and your customers are on the same page.

COME BACK AGAIN SOON – MANAGING RE-ORDERS

If the retailer wants to re-order a really small quantity, it might not be worth the cost of producing the order. Since you're a new company and most of your orders will be small you have a few good options to handle scenarios like this. One is to follow up with some of the other stores you've sold to, to ask if they might be interested in re-ordering that style any time soon. If they weren't successful with the style you can offer to take the product back, sell it to the other store, and give the store that returned the product a credit on a future order. This way you've made both customers happy.

IF YOU'RE LATE, COMPENSATE

The cancel date the buyer and you agree to on the order form means that if for whatever reason that date is not met, the order is no more. If you promise a delivery date, do everything in your power, indeed beyond your power, to meet it. Even a few days' delay can be a big deal when a retailer loses the opportunity to sell something in the timeframe they had planned. If for whatever reason you happen to be late, acknowledge the issue and compensate for it, whether it is free shipping on the order or a discount on a future one. Make a judgement call on proper payback for the cardinal sin of lateness. You could also decide to overnight the order at your expense to eliminate or lessen the delay. With retailers you can't just say 'I'm sorry' and keep a good relationship; you need to show it.

ANALYZE YOUR SALES

To find success in just about any type of business you'll need to know how to make some educated assumptions about what will happen in the future based on what is happening in the present. Analyze your sales on an ongoing basis looking at what stores are buying what goods, and what trends are showing up in your business. Is your key item adding up to 40% of your sales? Are items under $50 accounting for 80% of your sales but are only about 40% of your total collection? Is some version of blue always your bestselling colour no matter what the season? Analyzing your sales on a continuous basis gives you deeper insight into your customers that you can use to improve your collection and your business as a whole.

PROJECT YOUR SALES AND PROFITS

Projections on sales are usually made from some type of historical data. Given that you're a start-up, you won't have that information in your first season. At the same time, you'll want some idea of how much you can sell to help you prepare for how much you might need to produce the products. You'll also want to come up with a goal for how much you can realistically profit from your business in the first few years.

If you're working with a showroom, they should be able to help you out with some initial projections based on their history with clients that have a similar line

Year 1	# of Stores (Cumulative)	Avg. Per Store	Ttl Units	Avg. Whol.	Avg. Cost	Avg. Profit $	Ttl Cost	Total Sales	Gross Profit	Overhead	Net Profit
Fall/Holiday											
Spring/Summer											
Total											

Year 2	# of Stores (Cumulative)	Avg. Per Store	Ttl Units	Avg. Whol.	Avg. Cost	Avg. Profit $	Ttl Cost	Total Sales	Gross Profit	Overhead	Net Profit
Fall/Holiday											
Spring/Summer											
Total											

Year 3	# of Stores (Cumulative)	Avg. Per Store	Ttl Units	Avg. Whol.	Avg. Cost	Avg. Profit $	Ttl Cost	Total Sales	Gross Profit	Overhead	Net Profit
Fall/Holiday											
Spring/Summer											
Total											

3 Year Net Sales	$		3 Year Net Profit	$

to yours. If you're doing your own sales think about your sales strategy, how many stores you can target and how many stores you believe you can realistically get to buy your product. After that you can estimate an average order size based on a small entry-level order for your collection, and then do the math based on your average wholesale price to come up with some initial sales projections. Add in other elements such as average cost to determine the profit on your products, and extract overhead costs to get to your net profit.

Create an Excel worksheet like the one on the opposite page so that you can play around with different scenarios to work out how you can reach your business goals.

GETTING PAID

New designers are easy targets for getting screwed on payments by stores that may simply feel like they have other financial priorities. Believe it or not, it can be a challenge getting paid by even the most glamorous boutiques. If you've ever talked to anyone who's sold to speciality boutiques, they will tell you to get your money before you ship. If you're not paying a factor to collect payment for you, there are a few codes of best practice that will help ensure you collect your cheque.

BEST PRACTICES FOR GETTING PAID

1 **REQUEST A CREDIT CARD** when taking the order and get permission to keep the card on file till shipment. Not every store will go for this but it's worth a shot. Be clear that you have this policy in place to help ensure on-time delivery, and that the card will not be charged until the order is shipped.

2 **INVOICE OR CALL BEFORE SHIPPING.** About a week before you expect to ship send a Paypal invoice or give the buyer a call to obtain credit-card information. Make sure the most accurate expected ship date is on the invoice and is within the original shipping window you promised. Since some stores deal with limited shelf and storage space they are not often keen on receiving products early.

3 **CHECK CREDIT.** Online services like Dun & Bradstreet provide business credit ratings that you can check even before you accept an order. When using credit-card payments prior to shipping, if you have already produced the goods and a company can't or doesn't pay for them, it will be your loss. So no matter what method of payment, if they are not paying in advance, check the store's credit. Also network with other designers in your category to get the scoop on which stores have a reputation for paying late or not at all.

GIMME SOME CREDIT

This has been said already, but can't be repeated enough. Make every attempt to avoid extending credit, even if it means losing a large order. Many companies will request to pay net 30, 60 or 90, meaning they submit payment 30, 60 or 90 days after the product has been delivered. This is no position for a start-up company. You are not a bank and cannot afford to extend credit, even if the store happens to have good credit on a business credit reporting service like Dun & Bradstreet. Make every attempt to work with customers to secure the order, but if you have to, never be afraid to walk away.

BUSINESS MANAGEMENT SOFTWARE

Who can keep up with it all? How much it costs to manufacture each item, how much fabric you have available, the specs for each style, the total quantities you need to produce for each style, sales commissions, purchase orders. No matter how good you are at managing Excel spreadsheets, it is much easier to have a system that can help you manage all these moving pieces and the way they work together. While having business management software is not a must-have in the beginning, you may want to start investigating options to see what value they can add as you grow.

Using Apparel business management software can help you get organized, keeping all the important information about your business in one central system. I recommend AIMS software (Apparel Information Management Systems, www.aimstsi.com), which has proven itself highly valuable in helping some of my clients save money and time and successfully manage their businesses. Other options include Apparel Magic (www.apparelmagic.com), Blue Cherry (bluecherry. com) and Idalica (idalica.com). You can evaluate these systems based on their price, features, flexibility and training options.

GROWTH STRATEGIES

I know you're just getting started, but what's your next move? How do you want to grow? Think about utilizing some of the avenues below and making them a part of your grand plan.

OPEN A RETAIL STORE

Are you ready to go retail? If you've started by selling your line directly to retailers, opening up your own retail store will be an entirely new business model for you.

You'll have to hire salespeople and manage inventory, as well as serve and market to local consumers. It's a whole new ball of wax.

However, retail can be a great growth vehicle from both a sales and a marketing perspective. Some designers will open up a small boutique on or near an elite shopping district with the main goal of brand association with other elite stores on the street. Tory Burch launched her first collection and retail store at the same time by parking her new brand in the trendy Nolita neighbourhood in NYC. With such a buzz surrounding her store opening and line, she is famous for selling out the entire store on her first day of business.

GROWTH STRATEGIES

EXPLORE NEW CATEGORIES

The lifestyle-brand concept has permeated our society. We not only dress ourselves, we also dress and merchandise our whole lives, from our homes to our kids to our laptop case. While there are many nuances in every market — maternity, baby, men's, shoes, hats, house wares and more — since you have already made some inroads in producing products and establishing a brand, expanding your categories from contemporaries to juniors, for example, can be seen as a natural growth vehicle for your business. Always launch with the more aspirational market. While juniors may be keen on early access to a contemporary brand, a contemporary woman is unlikely to be interested in a teen brand.

LICENSE YOUR NAME

Certain things are better produced by experts. With items such as fragrances, swimwear and eyewear you may decide to license your name to a company that will sell and produce your product independently. Note that you must have pretty strong brand recognition before any type of viable licensing deal becomes an option. Until then focus on what you know how to produce yourself.

SELL ONLINE

If this wasn't a part of your initial strategy, selling online or expanding upon your ecommerce efforts is a necessary strategy for growth. Selling online allows you to get to know your customers and react to their wants and needs without delay. It can also be a bustling revenue stream if you invest the time to market your brand online.

KNOCK YOURSELF OFF

I've always told clients to start at the top. One reason to start by producing a higher-priced line is that, as you grow, you may want to knock yourself off with

a lower-priced volume-driving iteration. Think Marc by Marc Jacobs, Michael by Michael Kors, or even capsule collections like Temperly for Target. These lower-priced diffusion brands can be huge revenue streams once your brand reaches a certain level of visibility. To keep yourself open to this possibility you must start with a higher-end concept for your company. If you've established yourself as a lower-end or mid-priced brand, it will be hard to grow into a luxury brand.

EXIT STRATEGIES

Do you want to own an apparel line for the rest of your life? Maybe you have other life goals or plan on eventually selling your first company to start something new. Normally when a business reaches a certain level offers start coming in from private equity firms or larger conglomerates interested in getting a piece of the pie. Sometimes these buyout arrangements keep the founders on board as senior-level executives or as a part of a board. After selling their company to Liz Claiborne, Juicy Couture founders Pamela Skaist-Levy and Gela Nash-Taylor resigned their posts as Co-Presidents and took on the role as Co-Creative Directors in order to focus on fashion as opposed to the complexities of running a business.

APPENDIX ONE
BUSINESS ACTION PLAN WORKBOOK

USE THIS WORKBOOK TO UNDERSTAND IMPORTANT THINGS YOU NEED TO THINK THROUGH AS WELL AS ACTION STEPS YOU'LL NEED TO TAKE IN ORDER TO STRUCTURE YOUR BUSINESS.

COMPANY NAME:

What is your official company name? This name doesn't have to be the same as your brand name, as there may eventually be many different brands owned by your company.

BRAND NAME:

What is the brand name of your company? Read more about creating a brand name in Chapter 2.

LEGAL BUSINESS STRUCTURE:

You'll want to solicit personalised expert advice on which business structure will be best for your circumstances and your goals.

The legal business structure you choose for your business can have major implications on taxes, government requirements and personal financial liability. In the UK, the government-hosted website Business Link (www.businesslink. gov.uk) is packed with information as well as a hotline number residents can use to help them choose the appropriate business structure. In the US business structure information is clearly detailed on the website of the US Small Business Administration (www.sba.gov), and the free consultants at SCORE (www.score.org) can help you choose the right structure as well.

YOUR ASSORTMENT

Decide the types of product you will produce and the total size of your product line. Depending on the simplicity of the products, a final sample can cost from $500 at the lower end to $1000 or even more if the sample involves numerous patterns, materials and revisions. Products like denim, which often requires washing, and speciality treatments to achieve a distinct look, or products made out of expensive materials such as leather or cashmere, will be on the higher end of the spectrum, while products like T-shirts will cost much less to develop. Source out your materials and meet with a patternmaker or pre-production service to give you a starting point on costs for the product you want to create. Decide how big your product line will be and this will indicate how many samples you need to produce.

Description of your products

No. of styles in your product line

Average development cost per sample

PRICING

The price of your wares should correlate to your brand, category and direct competition. Take the perceived value of your product (how much does my product look like it would cost?) and measure it against the cost of producing your garments, making sure you can mark up by 2.2 and still have a fair price.

Average cost of your products

Average wholesale price

Average mark-up

Average retail price

SALES

What is your sales strategy? Will you sell direct, online or wholesale to retailers and boutiques. Will you acquire a showroom or start the sales process yourself?

Who are the top 10 retailers you'd like to sell to?

UNIQUE SELLING PROPOSITION

What does your line have over other comparable lines in the marketplace? Is it your wide assortment of colours, unique prints, special fabrics or fit? Identify what you'll focus on developing to make your line special.

WHAT ARE YOU REALLY SELLING?

Focus on the emotions behind your product. What emotional need are you filling for your customer? Status, energy, motivation?

COMPETITIVE ANALYSIS

Describe the brands and offerings of your key competitors. What do their assortments typically consist of? What is the average price point? What stores do they sell to? How do they promote themselves? Note how you fit into the overall marketplace.

Competitor 1

Competitor 2

Competitor 3

DESCRIBE YOUR CUSTOMER

Gender Age range Income

Where they shop

Hobbies

What do they value? Special causes? High quality? Low prices? Brand recognition?

Other brands in their closet

Brands they love the most or aspire to wear

Their celebrity style icon

Other things you know about your customer

DESCRIBE YOUR MARKETING STRATEGY

How will you gain the attention of your target customer? PR, web marketing, tradeshows?

What marketing materials do you need to produce to support your strategy?

PROFESSIONAL SERVICES TEAM

Search for these key players that can help you make important decisions about your company and save you from making costly mistakes.

Attorney/Solicitor: An attorney who specializes in the apparel industry could help educate you on laws that apply to your business including obtaining the licences you'll need to operate legally.

Attorney/Solicitor contact

Accountant. There are also accountants specializing in the garment business who understand the unique cash-flow structure of apparel businesses and can help guide you toward profitability.

Accountant contact

Business consultant. An apparel business consultant can give you insights on business management and direct you towards contacts in the industry.

Business adviser or mentor

Industry organizations you will join

OPERATIONS

OPERATIONS OVERVIEW

Describe an operations strategy for your company. Will you rent out an office space or reserve a special section in your apartment or garage? What are your responsibilities and what are the responsibilities of any partners you may have?

CONTRACTORS AND FUNCTIONS

Research who you will need on your team to help you and start making decisions about which contractors you will actually hire and what they are capable of doing for you. Ask for examples of their work and check references.

EXAMPLE

Contractors:

• Sales representative: handle sales and customer service

• Business consultant: create business plan

• Production manager: assist in coordinating sample production and sourcing materials.

FINANCES

How much do you have to invest in your company? How much are you prepared to lose? To start a collection-based company with multiple styles you could be looking at between US$30 and100K (or even more) in start-up costs.

Money from personal savings

Personal assets you would be willing to leverage

Money you can borrow from personal sources

RESEARCH VENDORS AND SUPPLIERS

Once you've determined the type of product you want to produce and at what price point, you'll need to start gathering the people and resources to create your products. You can start the research process looking through trade publications such as *Women's Wear Daily*, *Drapers* and *Sportswear International* as well as online sites such as weconnectfashion.com and fashiondex.com. Once you have some contacts on the table you'll need to start reaching out to vendors and suppliers, comparing the prices and quality of the services and materials they are selling.

PRODUCTION SUPPORT TEAM

Sample maker

Patternmaker

Cutter

Computerized marking and grading company

Garment dyeing company

Finishing company

PRODUCT VENDORS

Fabric

Buttons

Product labels

Care labels

Lining

START-UP TIMELINE

Plan out the launch of your collection, starting from the point when you have the money in place to truly get started. Even if you decide not to attend a tradeshow, choose a launch date around the same time as a show you would have considered going to. Doing this will put you in the flow of the sales season.

SAMPLE TIMELINE FOR FALL LAUNCH

YEAR 1

AUGUST–SEPTEMBER

Design and material sourcing
 for fall launch
Finalize designs to sample
Order fabrics and trims
Attend sourcing show

OCTOBER–DECEMBER

Product development for fall launch
Photo shoot
Website development
Marketing plan begins
Tradeshow preparation

YEAR 2

JANUARY–FEBRUARY

Website launch
Attend first tradeshow –
 Project, Las Vegas
Begin sales efforts
Spring/Summer product
 development begins
Spring/Summer show
 preparation begins

MARCH–JUNE

Online store opens
Fall production begins

JULY–SEPTEMBER

Fall collection launches in stores
Begin Spring/Summer sales
Attend Spring/Summer Bread
 and Butter Show
Attend Spring/Summer Project Show
Receive first payments from stores

YOUR NOTES

YOUR NOTES

YOUR NOTES

APPENDIX TWO
SAMPLE BUDGETS

SAMPLE STARTUP BUDGET	QUANTITY	COST
COMPANY SETUP		
TRADEMARK FEES		
BUSINESS CARD PRINT AND DESIGN		
OFFICE SUPPLIES/MAILING SUPPLIES		
LEGAL STRUCTURE SETUP FEES		
LOGO DESIGN		
BUSINESS CELL PHONE/800 #		
EFAX		
BUSINESS CONSULTING/WRITING SERVICES		
LAPTOP/COMPUTER AND PROGRAMS		
MAUFACTURERS LICENSE		
BUSINESS STORAGE/WORK SPACE		
MISCELLANEOUS OFFICE EXPENSES		
PRODUCT DEVELOPMENT		
SAMPLE FABRIC AND TRIM COSTS		
SAMPLE CUT/SEW		
GRADING		
HANG TAGS/PACKAGING		
DUPLICATE SAMPLES		
MODEL FORMS		
FIT MODEL		
MARKETING		
WEB DESIGN		
LINE SHEET DESIGN		
PROMO POSTCARDS		
MARKETING FOLDERS		
MODEL		
PHOTOGRAPHER/PHOTO SHOOT		
RETOUCHING/GRAPHICS		
LOOKBOOK PRINTING		
MAILING/POSTAGE		

SAMPLE STARTUP BUDGET	QUANTITY	COST
WEB/ECOMMERCE		
ECOMMERCE STORE		
DOMAIN NAME + WEB HOSTING		
EMAIL MARKETING + DESIGN		
GOOGLE AD WORDS BUDGET		
ECOMMERCE SHIPPING SUPPLIES		
LOGISTICS		
QUICKBOOKS ACCOUNTING SOFTWARE		
ORDER FORMS		
SALES		
SHOWROOM RENT		
SALES PRESENTATION SUPPLIES		
SALES TRAVEL		
TOTAL		

1ST YEAR MONTHLY OPERATIONS	YEARLY
SALARIES	
RENT + UTILITIES + STORAGE	
SHOWROOM RENT/SALES FEES	
MARKETING EXPENSES	
FACTOR FEES	
PRODUCTION	
FINISHING SERVICES	
SUPPLIES	
SHIPPING	
DESIGN UPDATES	
MISCELLANEOUS	
TOTAL	

RESOURCES

TREND FORECASTING
Design-Options Color Trend Forecasting
 www.design-options.com
Stylesight Trend Forecasting Service
 www.stylesight.com
World Global Style Network
 www.wgsn.com

INDUSTRY NEWS
California Apparel News
 www.californiaapparelnews.net
Drapers
 www.drapersonline.com
National Retail Federation Smart Brief
 www.smartbrief.com
Sportswear International
 www.sportswearinternational.com
Women's Wear Daily
 www.wwd.com

MODEL RESOURCES
Elite Agency
 www.elitemodels.com
Ford Modeling Agency
 www.fordmodels.com
Model Mayhem
 www.modelmayhem.com
Premier Model Management
 www.premiermodelmanagement.com
Storm
 www.stormmodels.com
Wilhelmina Models
 www.wilhelmina.com

SOURCING AND MATERIALS
Alibaba.com
 Global sourcing portal
Fashiondex.com
 Online guide to fabric and trims
Mfg.com
 Global sourcing portal

FASHION INSPIRATION
www.sartoralist.com
www.streetpeeper.com

FASHION PACKAGING
Macher
 www.macher.com

TRADESHOWS
Bread and Butter
 www.breadandbutter.com
Designers and Agents
 www.designersandagents.com
Margin London
 www.marginlondon.tv
Pure London
 www.purelondon.com
ENK Shows
 www.enkshows.com
Magic International
 www.magiconline.com
Swimwear Association of Florida
 www.swimshow.com
Pure London
 www.purelondon.com
Thread Show
 www.threadshow.com

World Shoe Association
www.wsashow.com
Bubble London Kid's Trade Show
www.bubblelondon.com
White Gallery London Bridal Show
www.whitegallery.com

DESIGNER NETWORKING AND INFORMATION

Fashion Incubator
(fashion business educational site)
www.fashionincubator.com
Centre for Fashion Enterprise (business
incubator for emerging designers)
http://www.fashion-enterprise.com
British Fashion Council (international
support for British fashion designers)
www.britishfashioncouncil.com
Thread Me (fashion business forum)
www.threadme.com
London Fashion Networking
(creative industry networking service)
www.londonfashionnetwork.com
Fashion Capital (fashion industry portal)
www.fashioncapital.co.uk

FACTORS

FTC Commercial
www.ftccc.net
Goodman Factors
www.goodmanfactors.com
Factoring Advisory Service
www.factoringadvisoryservice.co.uk

APPAREL BUSINESS SOFTWARE

Apparel Information Management Systems
www.aimstsi.com
Blue Cherry
www.bluecherry.com

SOCIAL MEDIA MARKETING

Fashionably Digital
www.fashionablymarketing.me

BLANK COMPANIES

Alternative Apparel
www.alternativeapparel.com
American Apparel
www.americanapparel.net

ONLINE STORE SET-UP

Godaddy.com
Volusion.com

BUSINESS CREDIT REPORTING SERVICE

Dun and Bradstreet
www.dnb.com

PRE-PRODUCTION AND PRODUCTION COMPANIES

Association of Suppliers to British
Clothing Industry
www.asbci.co.uk
Garment Solutions
Contact: Thelma Siguenza
Tel: +1 (213) 210 7422
Email: garment@sbcglobal.net
S.J. Manufacturing
Tel: +1 (415) 597 7500
www.sjprivatelabel.com

SMALL BUSINESS RESOURCES

London Development Agency
http://www.lda.gov.uk
SCORE (free business mentoring)
www.score.org
US Small Business Administration
www.sba.gov
Small Business (information website)
smallbusiness.co.uk

INDEX

CONTACT THE AUTHORS

RALINDA HARVEY

Gloss Marketing

Business consulting

Email: ralinda@glossmarketing.com

Web: www.glossmarketing.com

KATHARINA PRETL

Lana Futura

Fashion design, illustration and merchandising

Email: office@lanafutura.com

Web: www.lanafutura.com

MORE QUESTIONS?

Follow us online at our Trendsetter's Guide
website: www.atrendsettersguide.com